IMAGES
of America

JEWISH LIFE IN
OMAHA AND LINCOLN

A PHOTOGRAPHIC HISTORY

This book is compliments of

Jewish Federation of Omaha
ℱoundation

(402) 334-6440
mricks@jewishomaha.org

Steven Bloch *Marty Ricks*
President *Executive Director*

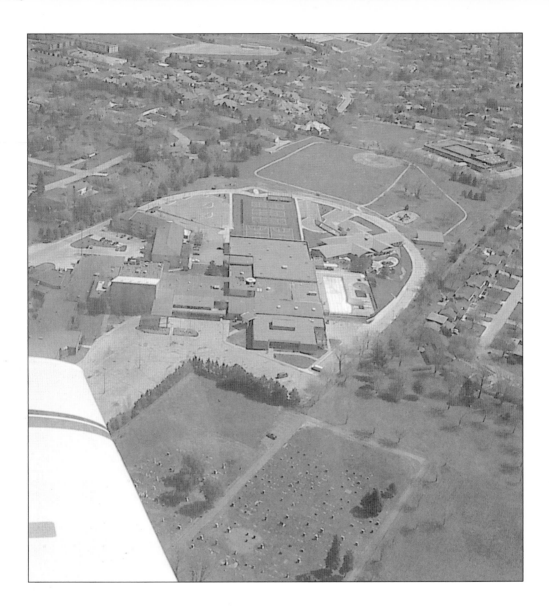

The Jewish Community Center opened in 1973 at 333 S. 132nd Street. This aerial photo was taken in 2001. The relocation of the JCC from downtown influenced a substantial amount of secondary real estate selection as families and synagogues moved west. The JCC houses the Jewish Federation of Omaha, Foundation, the Kripke Jewish Federation Library, Nebraska Jewish Historical Society archives, Henry and Dorothy Riekes Museum and Belzer Family Gallery, Jewish Press, Bureau of Jewish Education, Pennie Z. Davis Child Development Center, Gordman Center for Jewish Education housing the Friedel Academy, theater, art gallery space, dance and music studios, meeting rooms and class rooms, Rose Blumkin Jewish Home, the Herbert Goldsten Synagogue, Livingston Plaza Apartments, two olympic-size swimming pools, baseball, soccer, basketball, tennis, and hand ball facilities, two indoor running tracks, men's and women's health club, and the Phil Sokolof Health and Fitness Center. Campus expansion in 1999–2000 cost over $9 million. (Courtesy of Jewish Community Center.)

IMAGES
of America

JEWISH LIFE IN
OMAHA AND LINCOLN

A PHOTOGRAPHIC HISTORY

Oliver B. Pollak

ARCADIA
PUBLISHING

Published by Arcadia Publishing
Charleston SC, Chicago IL, Portsmouth NH, San Francisco CA

Printed in the United States of America

Library of Congress Catalog Card Number: 2001093675

For all general information contact Arcadia Publishing at:
Telephone 843-853-2070
Fax 843-853-0044
E-mail sales@arcadiapublishing.com
For customer service and orders:
Toll-Free 1-888-313-2665

Visit us on the Internet at www.arcadiapublishing.com

To Karen Goldstein Pollak and Mary Arbitman Fellman

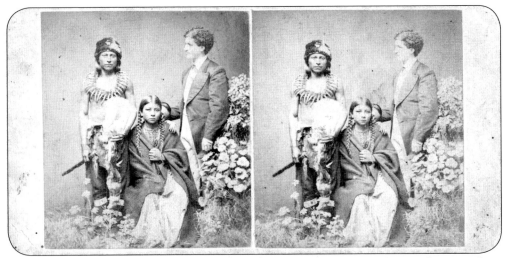

Julius Meyer, born in Germany in 1851, arrived in Omaha in 1866 and opened a curio shop. He paid Native Americans to pose in this stereopticon. On the reverse of this stereopticon he advertises "all kinds of Indian, Chinese, and Japanese curiosities," buffalo, beaver, mink, and otter furs, and a variety of photographs. (Courtesy of Nebraska State Historical Society.)

CONTENTS

ACKNOWLEDGMENTS

The author would like to thank the Nebraska Jewish Historical Society, which he helped found in 1982, for gracious access to its invaluable collection. Mary Fellman's unstinting encouragement, the support of archivist Barbara Bresler, and the helpfulness of Dottie Rosenblum and Reneé Corcoran have facilitated this project. Chad Wall at the Nebraska State Historical Society and the Historical Society of Douglas County have also rendered assistance. Jennie Gates at the Omaha *Jewish Press* and David Beckman assisted immeasurably in scanning the photographs that could not leave the premises. The Carl Frohm Foundation, directed by Dean Frankel, provided financial support that made it possible to produce this volume in an expeditious and timely manner. I thank the University of Nebraska at Omaha, where I have taught since 1974, for their continuing support for various research and writing projects.

This topic departs from a conventional text based history. Having always been interested in photography, I took the opportunity of teaching a night course to Jewish adults at the Jewish Community Center and framed the class around the preparation of this book. My students cooperated wonderfully as a "focus group." In four evening sessions local Jewish photographers Larry Kavich, Ophir Palmon, Eliska Greenspoon, Paula Friedland, and Annie Hershey, filmmaker from San Francisco, presented cameos of their work, from which I acquired a greater understanding of the thought processes and emotion behind the camera.

Nebraska, Jews, and photography is a special story. Jews were among the early professional photographers in the state. Heyn had an Omaha studio in the 1870s. Nebraska novelist Wright Morris, born in Central City, lived in Omaha in the 1920s where he was indelibly affected by Jewish culture, experimented with photography and text from the late 1930s, which in his own assessment met with mixed commercial success. Morris sought creativity to accompany his stark Nebraska black and white images. Tillie Lerner Olsen, one of Nebraska's greatest writers, contributed to a photo essay published by *Aperture*, "Mothers & Daughters" (1987). Our task here has been made easier, the production of an historical narrative to accompany the image, by the pioneers who preceded us.

The walls of the Jewish Community Center contain over 400 well-displayed photographs depicting Jewish life (communal activities, landmarks, youth, weddings, business, and aging) in Nebraska. Unless otherwise noted, the pictures in this book come from the archives of the Nebraska Jewish Historical Society.

The standard printed works on Jewish Omaha are chronologically framed by 1850–1927, 1850–1913, 1880–1920, and 1880–1925. Thus the history of Jewish life for the bulk of the 20th century remains to be written, and it is hoped that these pictures are a preview of written text to follow.

INTRODUCTION

Immigration, settlement, and the building of an ethnic community in the Midwest is an exciting chapter in the big story of becoming American. From the mid-1850s when Jewish peddlers on the frontier traded with Indians and homesteaders to the present, Jews have played a significant part in the development of Omaha, Nebraska, and the Midwest.

The record of the Jewish contribution in Nebraska is found in newspapers, books, and fragile memories. Our story here is based on photographic images. Some of the pictures were posed and contrived, some are candid. Some are intimate portrayals of the Jewish life cycle from Sunday school and Bar Mitzvah, to weddings and other religious celebrations. Some pictures capture economic development from humble beginnings to major commercial enterprises. Images of the interiors of businesses permit us to see the progression in consumer and material comfort and the methods of merchandising. Photos of corner stones and construction reveal the architecture of a community, places of worship, communal activity, and repose in cemeteries, and its impact on the face of the city. We depict women and men in their everyday lives, at prayer, work, and play.

Then there are the photographic images of personalities almost larger than life, the pioneers of intellect, commerce, and politics. Jews have contributed to Nebraska politics as mayors, councilmen, congressmen, senators, and Supreme Court justices. Financiers built suburban subdivisions. Physicians treated patients. Lawyers and judges presided over legal disputes. Rabbis cared for the spiritual and moral needs of their congregations. Many communal leaders volunteered their time and talent to improve local and international Jewish life. Wolbach, Nebraska, is named after a German Jewish immigrant.

In the early 20th century there was a Jewish presence in over 30 Nebraska towns. By 2001 almost 90 percent of Nebraska's approximately 8,000 Jews live in Omaha, and most of the balance is in the capital city of Lincoln. Omaha and Lincoln are 50 miles apart and there is substantial contact between the two communities. Many claim the University of Nebraska as their alma mater, have friends and relatives in both cities, are kindred spirits following Big Red Cornhusker football, and share common Jewish resources. The Jewish presence in Columbus, Fremont, Grand Island, and Hastings, Nebraska, and Council Bluffs and Sioux City, Iowa, manifested in commerce and the occasional B'nai B'rith Lodge, has collapsed and the out-migration from small towns has accrued to Omaha and Lincoln.

Settlement, the Depression, the Holocaust, the establishment of the State of Israel, and modern life attract the amateur and professional photographer who preserves the snapshot, the momentary pleasure and pain, with a Brownie camera or the most sophisticated state of the art digital technology. Omaha Jewry during the 20th century maintained a rich communal patina. Temples, synagogues, cemeteries, and community centers dot the urban map. But there were limitations. Jewish day-school education does not go beyond the 6th grade. Sustaining a

Kosher butcher has not been possible. The community has made effective accommodation with the larger Christian community, and has maintained a vibrant identity. Omaha Jews created a balance in the Jewish community marked by cooperation between the earlier arriving German Jews and the later arriving Eastern European Jews, a phenomena perhaps noted as an exception rather than the rule. At the end of the century there was a substantial feeling of community and identity over the range of observant and non-observant, from Reconstructionist to Lubavitch. This solidarity encouraged a multi-million dollar investment based on meticulous long-range planning in upgrading the communal infrastructure.

Lincoln's permanent Jewish population reached perhaps 1,200 in the 1920s and now hovers tenuously at about 600. It maintains two houses of worship but did not acquire an active Jewish community center. The University of Nebraska had Jewish fraternities and sororities until 1996 and does not maintain a Hillel House. Nebraska's Jewish college-age students, if they stay in the Midwest, prefer to go to universities in Illinois, Indiana, Kansas, Missouri, and Wisconsin.

Going through several thousand photographs and narrowing it down to 600 and then picking about 230 finalists comprises my interpretation of Jewish life in Nebraska. Another author may have tipped the scales a little differently, perhaps more on labor, less on something else, but I think this is fundamentally the right picture. I have been looking forward for several years to preparing this book. During this time the Nebraska Jewish Historical Society grew from an idea in 1982 into the Carl Frohm Archival Center containing over 400 linear feet of documents and photographic images, the Henry and Dorothy Riekes Museum, and the Belzer Family Gallery. Its richness is attested by the support it gave to the publication of several scholarly articles. This photographic history purposely concentrates on pictures, almost none of which have been previously published.

One

PIONEERS AND REFUGEES
150 YEARS OF IMMIGRATION

Jews arrived in the Midwest from two directions and in four waves. In the 1850s Jews left political disappointment in Germany, Austria, and Bohemia, and arrived in Nebraska, sometimes via Cincinnati and Wisconsin, by stagecoach and riverboat. The Union Pacific eased transport difficulties and later immigrants were called refugees, immigrants, and settlers rather than pioneers. The second wave starting in the 1880s comprised refugees fleeing persecution in Eastern Europe. Many got off the boat in New York and then took the train to Omaha. Another significant group left Hamburg, Germany, and arrived in Galveston, Texas, from where they were dispersed to Midwestern cities. The third wave came after the Second World War and included survivors and other displaced persons of the Holocaust. Finally, from the 1970s Jews arrived by jet at Eppley Airport from the Soviet Union, and after 1988, Russia.

There are many Jewish families and businesses that have been in Omaha for four and soon to be five generations. Within Omaha, Jewish family residences, synagogues, and communal facilities gradually moved from the downtown area to the western suburbs. Nebraska winters are notorious, the summers are hot and muggy, and spring and fall are all too short. Weather is not everything. Many Omaha Jews stayed only a few years before they moved on to Chicago, Denver, or California for larger Jewish communities or for professional and economic reasons. "Snowbirds" have established residences in Arizona and Florida. Many Jews in America still recall that there is an "Omaha" in their family's past.

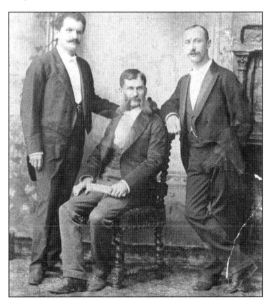

Omaha businessmen Emil Brandeis, A. H. Gladstone, and Julius Meyer had roots in Bohemia, Hungary, and Germany. Emil, son of Jonas L. Brandeis, founder of Brandeis Department Store, died on the *Titanic* in 1912. Gladstone described Omaha as having 25 hotels, 200 saloons, 15 cigar stores, 6 fine milliners, and 6 wholesale groceries. The Gladstones opened the Omaha Hoop Skirt Factory. Meyer's Wigwam, a curio store, attracted tourists.

Pogroms in Eastern Europe triggered a "tidal wave," "avalanche," and "Third Migration" of Jewish refugees, numbering over 2 million between 1881 and 1914. Most Jews settled in New York, some ventured inland. On July 14, 1882, 161 Russian Jews arrived in Omaha, some went on to Lincoln. The Industrial Removal Office resettled over 2,000 Jews in Nebraska between 1901 and 1917, peaking at 366 in 1907.

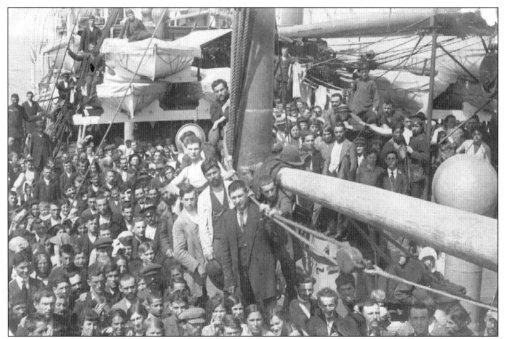

Philanthropist Jacob H. Schiff wanted to divert immigrant Jews concentrating in New York and creating new ghettoes. Schiff devised the Galveston Plan. From 1907 to 1914, about 10,000 Jews traveled from Hamburg, Germany, to Galveston, Texas, to be dispersed in the middle of America. A photographer assembled the passengers, took a picture, and sold postcard keepsakes. (Photo courtesy of Dina Bloom and Susan Witkowski.)

NAME	SIZE OF FAMILY	OCCUPATION	DATE OF SET-LEMENT ON HOMESTEAD	DATE OF LEAVING
Jacob Levine	4	Machinist	1908	1915
Louis Offengended	2	Tinsmith	1910	1915
Harry Rosenbaum	4	Tailor	1909	1915
Israel Miller	1	Shoemaker	1909	1915
Mendel Bernstein	3	Carpenter	1908	1916
Samuel Rotsman	10	Tailor	1908	1915
Joseph Gold	5	Tailor	1909	1915
Louis Gellman	1	Tailor	1908	1913
Harry Cohen	4	Carpenter	1908	1915
Morris Mearsen	5	Machinist	1908	1915
Hyman Schwartz	1	Shoemaker	1908	1914
David Singer	5	Carpenter	1908	1916
Sam Zabow	1	Tailor	1908	1913

This page reprinted from Ella Fleishman Auerbach's "Jewish Settlement in Nebraska" (1927) identifies several of the immigrants diverted from the trades and professions, to an agricultural settlement in Cherry County in north central Nebraska. This valuable sociological information reveals family size, occupation, and dates of arrival and departure from this unsuccessful agricultural community, sponsored by the Jewish Agricultural Society.

Night schools were established in neighborhood schools to prepare immigrants for citizenship. The Americanization program included instruction in the English language and American history. European accents and the use of Yiddish ended with the immigrant generation. The United States Government provided textbooks for the classes. Much of the program was presented by well-meaning and financially secure Jewish women. These programs assisted in the demise of the Yiddish.

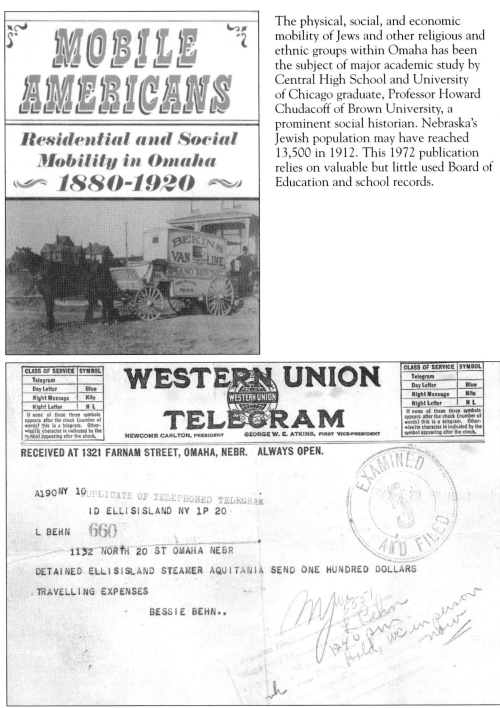

MOBILE AMERICANS

Residential and Social Mobility in Omaha
~ 1880-1920 ~

The physical, social, and economic mobility of Jews and other religious and ethnic groups within Omaha has been the subject of major academic study by Central High School and University of Chicago graduate, Professor Howard Chudacoff of Brown University, a prominent social historian. Nebraska's Jewish population may have reached 13,500 in 1912. This 1972 publication relies on valuable but little used Board of Education and school records.

CLASS OF SERVICE	SYMBOL
Telegram	
Day Letter	Blue
Night Message	Nite
Night Letter	N L

If none of these three symbols appears after the check (number of words) this is a telegram. Otherwise its character is indicated by the symbol appearing after the check.

WESTERN UNION
TELEGRAM

NEWCOMB CARLTON, PRESIDENT GEORGE W. E. ATKINS, FIRST VICE-PRESIDENT

CLASS OF SERVICE	SYMBOL
Telegram	
Day Letter	Blue
Night Message	Nite
Night Letter	N L

If none of these three symbols appears after the check (number of words) this is a telegram. Otherwise its character is indicated by the symbol appearing after the check.

RECEIVED AT 1321 FARNAM STREET, OMAHA, NEBR. ALWAYS OPEN.

A190 NY 10 UPLICATE OF TELEPHONED TELEGRAM
ID ELLISISLAND NY 1P 20

L BEHN 660

1132 NORTH 20 ST OMAHA NEBR

DETAINED ELLISISLAND STEAMER AQUITANIA SEND ONE HUNDRED DOLLARS

TRAVELLING EXPENSES

BESSIE BEHN..

Immigrants had passports, visas, and other travel documents from Russia, Poland, and Rumania. The immigration officers with the acquiescence of the immigrant created new, more American sounding names for these newcomers. Immigrants were frequently called "greeners" or green horns. Most immigrants arrived poor. This 1932 telegram announces Bessie Behn's arrival in America and her need for funds to make it to Nebraska.

Alvin Johnson was born in Homer, Nebraska, to Danish immigrants who were endowed with "Prosemitism." He attended the University of Nebraska and received a doctorate in economics from Columbia University. He was a founder and president of New York's New School for Social Research. He created a graduate school, the "University in Exile," and an agricultural colony in 1939, New Eden in North Carolina, for German refugees. The University of Nebraska maintains his papers.

AN AUTOBIOGRAPHY BY Alvin Johnson

PIONEER'S PROGRESS

THE NEBRASKA ZEPHYR...DAILY BETWEEN CHICAGO, OMAHA AND LINCOLN

Wagons, horses, and riverboats provided early transportation. Omaha, a railroad town, home of the Union Pacific Railroad, was also served by the Burlington Northern. Railroads advertised their services in Europe. Both railroads had grand architecturally-noteworthy stations in Omaha. Before the automobile, trucks, and economical commercial air travel, trains provided safe and regular transportation for passengers and goods from the east coast, as well as between large and small midwestern towns.

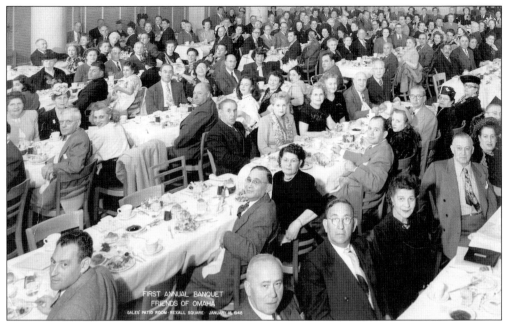

Omahans in Los Angeles became nostalgic. This First Annual Banquet of the Friends of Omaha in Los Angeles, January 18, 1948, was attended by about 200 people. Banquets and picnics came to an end by the early 1960s. Family reunions and major birthdays and wedding anniversaries see former Omahans from around the world converging on Omaha's synagogues and the Jewish Community Center.

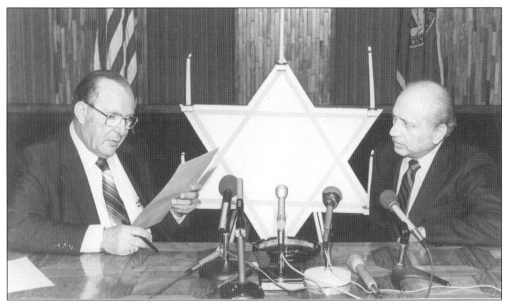

Holocaust Survivors, including hidden children, comprise a significant immigrant contribution to Omaha. Though few in number, they are vocal and visible. Here, Sam Fried, a charter member of the Omaha Holocaust Survivor's Society meets in a press conference with Omaha Mayor Al Veys in May 1981. Holocaust Survivors who have given public testimony and written books are Cantor Leo Fettman and Carl Rosenberg. They preside at the annual Yom Hashoah ceremony.

Bea Karp, born in Germany as Bea Stern, survived the Holocaust. She has given numerous presentations about her experience to Nebraska's public schools, youth groups, and churches. The monthly *New Horizons*, the leading senior citizen publication in Omaha, is widely available in the city. Ben Nachman has been very active in Omaha interviewing survivors for Steven Spielberg's Shoah Visual History Foundation.

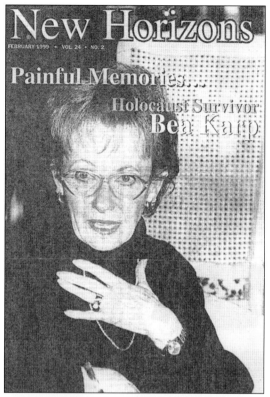

New Horizons

FEBRUARY 1999 • VOL. 24 • NO. 2

Painful Memories...
Holocaust Survivor
Bea Karp

Concern for Jews in the Soviet Union and Russia resulted in lobbying American legislators, writing letters to the editor, and cajoling and criticizing the Soviet Union. In Omaha, Shirley Goldstein pressed an indefatigable campaign pressuring the American government and Russia to release Jews. Here she is photographed in 1980 with Israeli Prime Minister Menachem Begin. Photo opportunities featuring Diaspora Jews and politicians started with David Ben-Gurion.

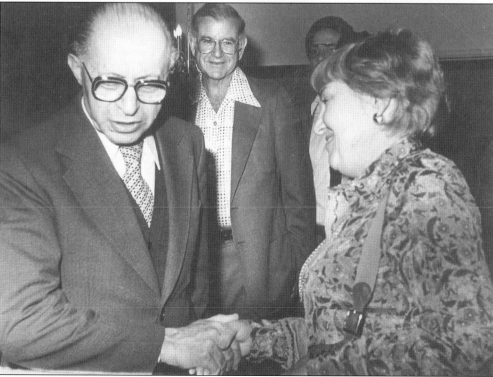

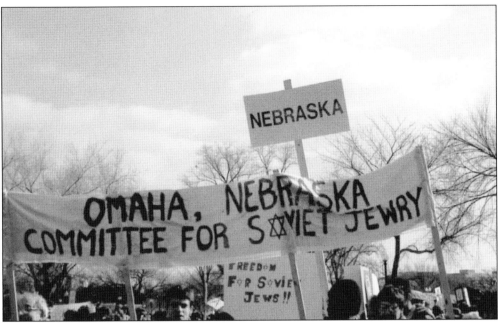

On December 6, 1987, the Jewish Federation of Omaha chartered an airplane to transport children and adults to a Rally for Soviet Jews on the Washington D.C. Mall. The plane left in the morning. The Omaha contingent joined over 100,000 Jews from all over the United States who participated in the march, and returned to Omaha at the end of the day. (Photo by Oliver B. Pollak.)

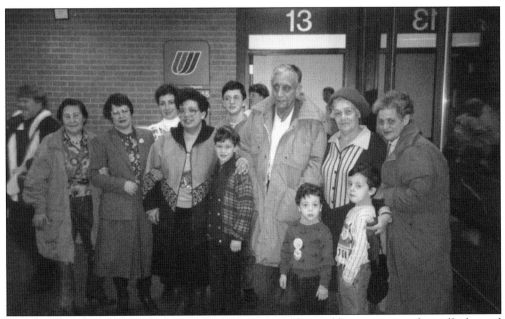

Russian Jews arrived by jet at the airport. They were welcomed by sponsors and a well-planned assimilation program facilitated by the Jewish Federation and Jewish Family Service that included housing, occasionally an automobile, and employment. Many of the new arrivals found a home in Omaha, and others moved to larger cities around the country. The picture includes members of the Sitnyakovskaya, Ginzburg, Treskunova, Zevakina, and Levit families.

Two

KEEPING THE FAITH
BRICKS AND MORTAR, HEARTS AND SOULS

The Jewish faith is founded in text, the Torah, the Hebrew Bible. The demands of faith lead to acquiring places for worship and burial, and for the establishment of food supplies that comply with the rules of Kashrut (Kosher food). Many early congregations rented pre-existing structures, community halls, Unitarian Churches, storefronts, and churches converted to synagogues. It was not long before congregational leaders established building funds to erect their own edifices. Jewish worship does not require a rabbi or cantor, but having these professionals indicates commitment and permanency.

The spiritual cycle of the Jewish calendar is built around the seven day week and observing the sanctity of the Sabbath, one of the Ten Commandments. The Jewish Year starts with Rosh Hashanah and Yom Kippur (New Year's Day and Day of Atonement). Passover (Moses leading the Jews out of Egypt), Sukkot, and Shavuot celebrate the seasons. Hanukkah and Purim are post-Biblical celebrations. There are Post-World War II remembrances, Yom Ha-atzmaut celebrating Israel Independence Day, and Yom Hashoah, a memorial for Holocaust victims. Within this cycle human events of birth, male covenantal circumcision (Bris), and a religious education program of Hebrew School or cheder leading to Bar or Bat Mitzvah at the age of 13. The joining of man and woman in wedlock is sanctified by the aufruff preceding the wedding under the chupa (canopy) and the ritual breaking of the glass. Funerals and Yahrzeit, the annual memorial to dead family members, mediates grief, consoles, and provides remembrance and respect for the dead.

This is Nebraska's first Jewish house of worship. Congregations progressed from minyons praying in homes, meeting at the Masonic Hall and Unitarian Church, renting space, and building their own sanctuary. Pictured here is the Congregation of Israel, later called Temple Israel, located at Twenty-Third and Harney Streets. Rabbi Leo Franklin at Temple 1892–98 and his successor, Rabbi Frederick Cohn, periodically ministered to Lincoln's B'nai Jeshuran, until Lincoln acquired a Reform Rabbi.

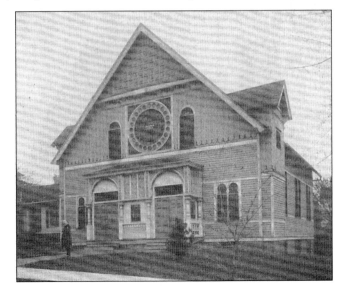

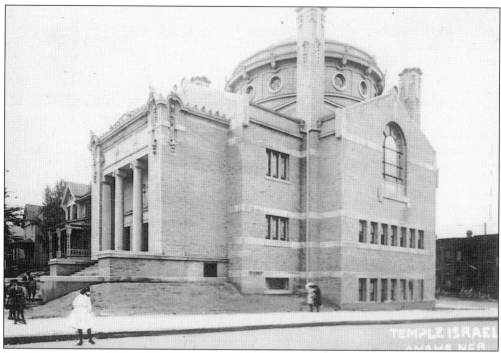

The congregation of Temple Israel grew in size and built this building in 1908 at Twenty-Ninth and Jackson Street of which there are several postcard views. It was described as "a monument of beauty, style, dignity, and massiveness and is worthy of the efforts expended in its erection." Sold in 1953 to St. John's Greek Orthodox Church, Temple Israel moved to its current location. (Postcard courtesy of Burnice Fiedler.)

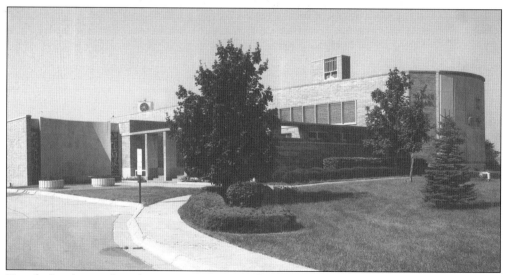

Temple Israel moved to the growing western suburbs in the early 1950s. It is adjacent to the Omaha Community Playhouse Theater and First United Methodist Church. Rabbi Sidney Brooks ministered to the congregation from 1952 to 1985. It received substantial damage from the 1975 tornado. Periodic updating includes pews replacing theater-style seats, ramps for wheel chairs, and additional classrooms. Its main sanctuary holding 300 can be expanded to 900.

Immigrants from different nations, regions, *geburnias* (Russian administrative districts), and *shtetls* attempted to maintain some old country atmosphere and fellowship in secular *landsmanschaft* and by creating distinct Lithuanian, Roumanian, Hungarian, and Russian congregations and cemeteries. This is the building built by the Russian Congregation founded in 1886, located at Twelfth and Capitol. Rabbi Henry Grodzinsky ministered to several orthodox congregations.

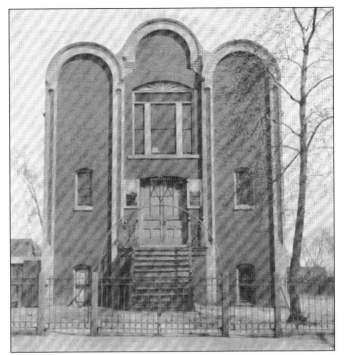

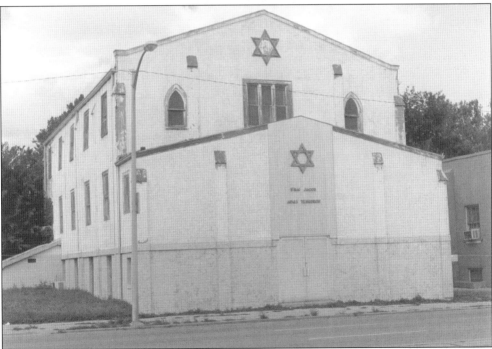

B'nai Jacob Adas Yeshuran (Kapulier Shul) was established in 1916. This building had a women's gallery and main floor for men. In 1940 the Labor Lyceum opened next door. An aging congregation resulted in its closure in 1985. The interior was recreated in the Nebraska Jewish Historical Society's Henry and Dorothy Riekes Museum. Today Nebraska Air Filter and the United Community Holy Spirit Church occupy the synagogue and Lyceum.

CERTIFICATE

THIS IS TO CERTIFY, that the Congregation Beth Hamedrosh Hagodel, a religious corporation in the State of Nebraska, with its principal place of worship in the City of Omaha, Douglas County, Nebraska has, in consideration of $ _145 00_____, the receipt of which is hereby acknowledged, agreed to grant and by these presents does grant to _Abraham Weiss_, and his heirs, the license and privilege for the use of one pew No._115_ for Gentleman, and one pew No. _54_ for Lady; in the Synagogue of the Congregation situated on lot four (4), block three hundred and forty-nine (349) in the City of Omaha.

This licence shall continue and remain in force for the benefit of the licensee herein and his heirs, so long as the conditions remain unbroken, it being understood that this licence is granted subject to all conditions and restrictions now imposed by the By-Laws of this Corporation and subject to any and all By-Laws that may hereafter be adopted and upon express condition further that the Board of Directors of said religious corporation shall at all times have full and complete control over the use of the privileges herein granted and the corporation may at its option for good and sufficient cause or upon breach of condition, revoke license and effect a surrender of this certificate, upon payment to the holder thereof the actual value of the license, in no case exceeding the sum paid therefor.

IN WITNESS WHEREOF, the undersigned corporation has by its officers executed this certificate and caused its corporate seal to be affixed on this _23rd_ day of _August_ 19_15_.

CONGREGATION BETH HAMEDROSH HAGODEL,

By _Louis Harris_
President.

Attest:-

Secretary.

Family memberships in synagogues, *aliahs* (being called to the *bimah* (central ritual area)) were voluntary and proprietary, and could award a degree of social status. This certificate reflects the formality and ensured that during the High Holy Days, when almost all Jews create an overflow crowd in services, that Abraham Weiss would have a seat at Congregation Beth Hamedrosh Hagodel (also transliterated Hagodol and Hagadol), the largest orthodox congregation.

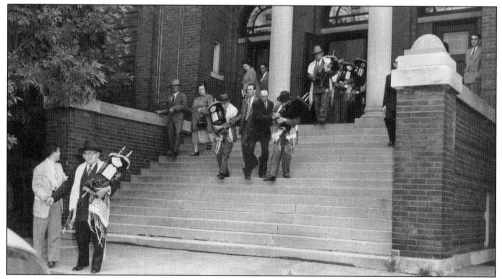

The closing of a synagogue is attended by a mixture of ritual, nostalgia, and sentiment and expectation of the new home. It is accompanied by ceremonies and usually walking through the city streets, with an accommodating Omaha Police Department escort, carrying the Holy Scrolls. Here B'nai Israel is closed in anticipation of moving to Beth Israel, which opened in 1953.

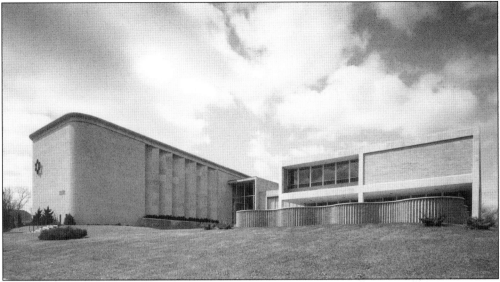

Beth Israel became home for the consolidation of separate Orthodox congregations. The first rabbi at Beth Israel was Rabbi Sydney Mossman who went to Detroit in 1953. Beth Israel is still in its 1953 structure and since the mid 1990s there have been proposals to move west to a location near the Jewish Community Center.

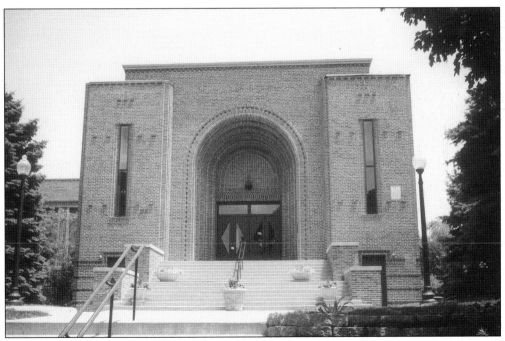

The Conservative movement arrived in Omaha around 1920. Beth El met at the Jewish Community Center. This synagogue at Forty-Ninth and Farnam opened in 1940. A classroom wing was added later. As the congregation migrated to the western suburbs and the building aged, the congregation decided to follow Omaha's westerly ribbon development. The building now serves as the offices for an architectural firm. (Photo by Oliver Pollak.)

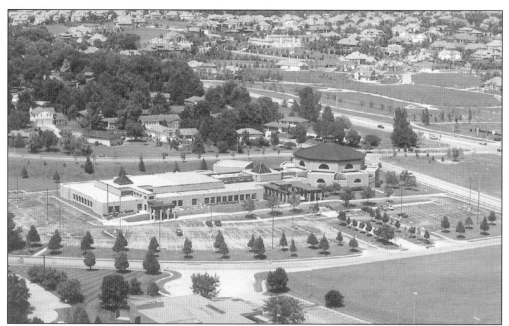

Beth El opened its new synagogue at 145th and Dodge Streets in 1991. Maurice N. Finegold designed it on a "central" rather than "processional" plan. The main sanctuary can seat 800 worshippers. The wooden interior suggests synagogues in Eastern Europe. The synagogue facilities were expanded to include a large social hall, kitchen, and a full range of state-of-the-art classrooms. (Photo courtesy of Aerial Photos, photo by Alan Jess.)

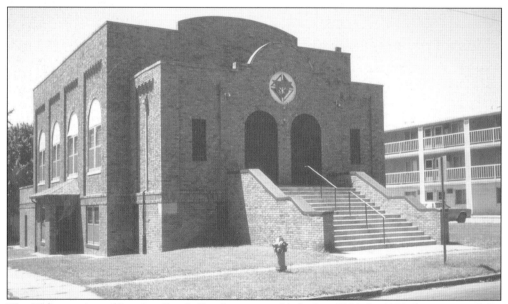

The Congregation of Israel in South Omaha was established in 1908. In 1909 they acquired the old First Presbyterian Church at Twenty-Fifth and J Streets. In 1927, it had 75 families with 50 children in its Hebrew school. South Omaha Jews gradually moved to neighborhoods with larger Jewish concentration. The congregation disbanded in 1961. The Knights of Columbus purchased the building.

Rabbi Isaac M. Wise, the leader of the 19th century American Reform movement, visited Lincoln in the Summer of 1877. He found six Jewish families. Temple B'nai Jeshurun, a Reform congregation, opened in 1884 with some services being provided from Omaha by Rabbis Franklin and Cohn. The first permanent rabbi arrived in 1906.

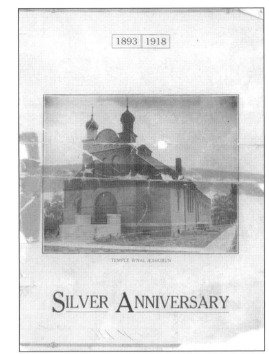

Temple B'nai Jeshuran's current temple was dedicated in 1924 at Twentieth and South Street, and it is sometimes referred to as the South Street Temple. Its architecture is a mix of Byzantine and Moorish. It is on the National Register of Historic Places and the spiritual home for 115 families. Cantor Michael Michael Weisser, officiating since October 1988, became a Rabbi in June 2001. (Photo by Oliver B. Pollak.)

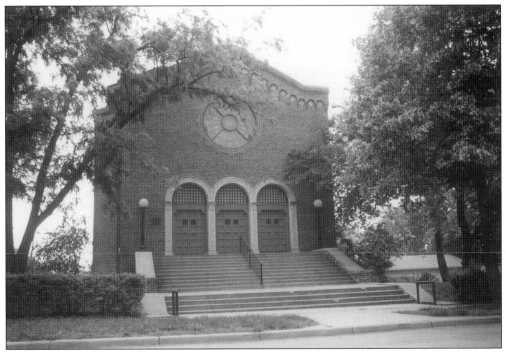

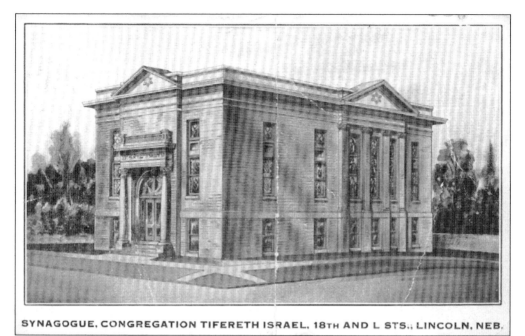

SYNAGOGUE, CONGREGATION TIFERETH ISRAEL, 18TH AND L STS., LINCOLN, NEB.

An orthodox congregation was formed in Lincoln in 1886. Congregation Talmud Torah purchased a parcel of land and merged with Congregation Tifereth Israel (Israel's Glory) in 1910–11. The new synagogue opened at Eighteenth and L Streets in 1913. Note the feeling of stability and grandeur emanating from the brick and the leaded stained glass windows.

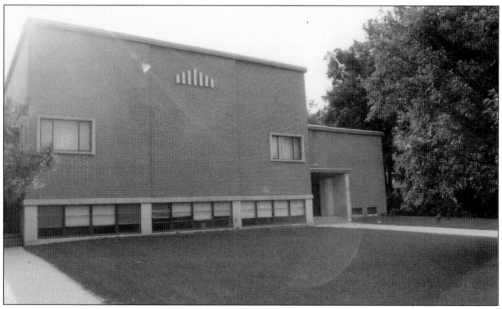

Tifereth Israel became Conservative in 1925 when it affiliated with the United Synagogue of America. It moved to its current location on Sheridan Blvd. in 1954. The early 1950s saw ambitious building programs in Nebraska with two new synagogues in Omaha and one in Lincoln. Two of its Presidents, Louis Finkelstein and Herman Ginsburg, served for 10 years. Tifereth Israel serves 150 to 175 families. (Photo by Oliver B. Pollak.)

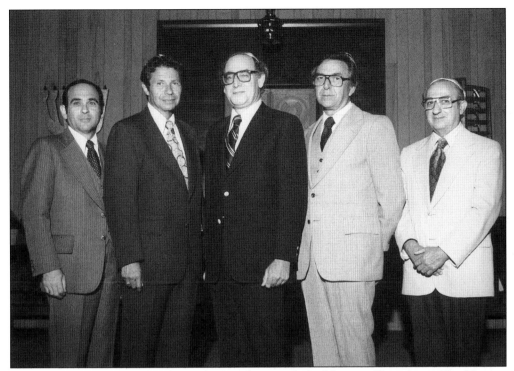

This picture of five of Tifereth Israel's presidents includes Norman Krivosha, a Chief Justice of the Nebraska Supreme Court, 1978–87, and vice president of Bankers Life and Ameritus; Gerald Grant, a CPA; Bernard Wishnow, an attorney; Sheldon Kushner, a businessman; and Harry Allen, University of Nebraska Director of Institutional Research. Allen retired with his wife, Annie Arbitman, formerly of Omaha, to live in Israel.

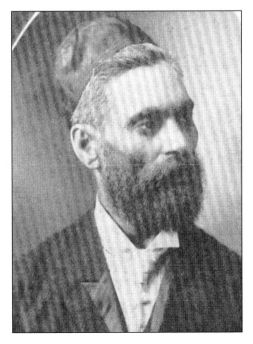

Rev. Esau Fleishman, from Lithuania, arrived in Omaha via Sioux City in 1888. He was a *mohel* (circumciser) and *schochet* (slaughterer). He helped organize the Omaha Hebrew Club in 1892, was vice president of Wise Memorial Hospital, local representative of the Industrial Removal Society, and kept a Kosher boarding house. His daughter Ella Fleishman Auerbach wrote "Jewish Settlement in Nebraska" (1927) and the *History of Medicine in Nebraska* (1928).

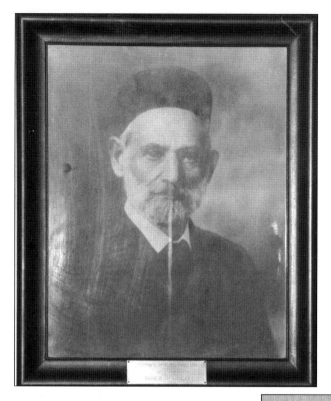

Rabbi Henry Grodzinsky (1873–1947), educated in Lithuania, arrived in Omaha in 1891, and was the first orthodox rabbi. He wrote three books on Jewish law, the manuscripts of which are in Israel. His daughter Helen was the first social worker engaged by the Associated Jewish Charities, and his daughter Rose became a teacher. His sons Manuel, a physician, and William, an attorney, changed their name to Grodinsky.

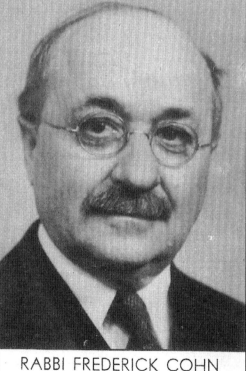

RABBI FREDERICK COHN

Rabbi Frederick Cohn (1873–1940) earned his divinity degree at Hebrew Union College and doctorate at the University of Nebraska. He served Temple Israel from 1904 to 1934 and sat on various community wide boards, such as the Community Chest. He debated Clarence Darrow on evolution. His son, Ralph, a University of Michigan educated chemist, moved to Chicago, changed his name to Colton, and died in 2000 at the age of 98.

Rabbi David A. Goldstein was the first Rabbi at the Conservative Beth El Synagogue. He introduced the "modern orthodox" idea in a 1928 sermon, and in November 1930, took the pulpit, which he served until 1946. A congregant wrote, "the rabbi...for 16 years... led us through rough times. This was greatly appreciated by those of us that wanted our congregation to grow."

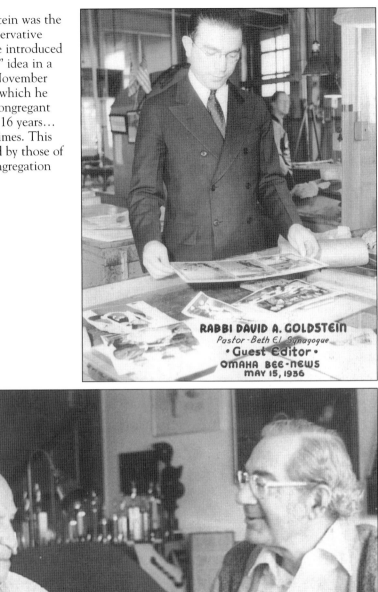

RABBI DAVID A. GOLDSTEIN
Pastor-Beth El Synagogue
• Guest Editor •
OMAHA BEE-NEWS
MAY 15, 1936

Judah L. Wolfson taught Hebrew School in 1923. He died in 1997 at the age of 106. Rabbi Myer Kripke came to Beth El Synagogue in 1946 and retired in 1974. His wife Dorothy wrote children's stories. Based on investments in Berkshire Hathaway, the Kripkes donated $7 million to rebuild the burned-out tower at the Jewish Theological Seminary where they had first met. The tower reopened in 2001.

Rabbi Harry Jolt served Tifereth Israel in Lincoln from 1928 to 1947. When he arrived the Jewish community had about 50 Reform and 125 Conservative families. He ministered to the needs of Jewish students at the University. His service as an Army Chaplain during World War II included a tour in Japan where he met Jewish servicemen from Omaha and Lincoln.

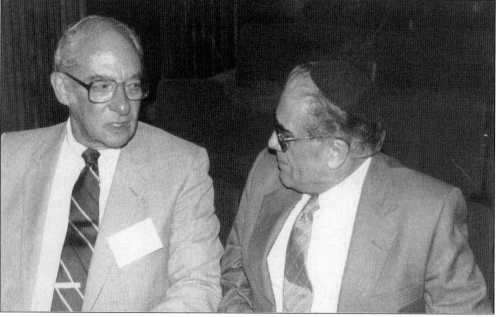

Rabbi Sidney Brooks served Temple Israel for 33 years, and was assisted after 1960 by a full time cantor. Rabbi Isaac Nadoff, on the right, ministered to Beth Israel Synagogue from 1965 to 1990. They presided over Bar Mitzvahs, weddings, and funerals, sharing joy and offering consolation. Both were loved and respected by their congregations and the wider Omaha community. Their wives, Rebbetzins, Jane Brooks, and Jeanette Nadoff contributed significantly to the quality of Jewish life.

Rabbi Mendel Katzman (seated) represents the Lubavitch movement in Omaha. Rabbi Paul Drazen came to Beth El Synagogue in 1982. Rabbis of the various branches of Judaism, lay educators, and leaders meet frequently in community education programs. The Lubavitch acquired supporters and purchased a church on 120th Street. They have an active religious education program that includes instruction in Yiddish.

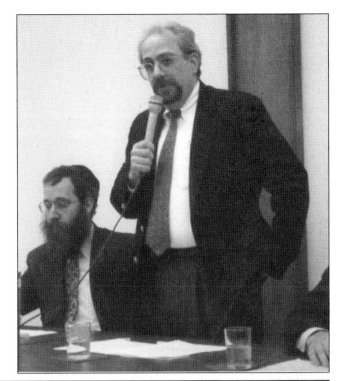

Rabbi Aryeh Azriel, an Israeli, arrived at Temple Israel in 1988 and introduced some traditional Jewish practices into the Reform program. He has been in the forefront of social issues involving race relations, gay rights, social justice, intermarriage, and conversion to Judaism, including participation in the Habitat for Humanity program. In this picture from 1991, he is talking at Temple Israel's Black Jewish Dialogue at the Milder Center.

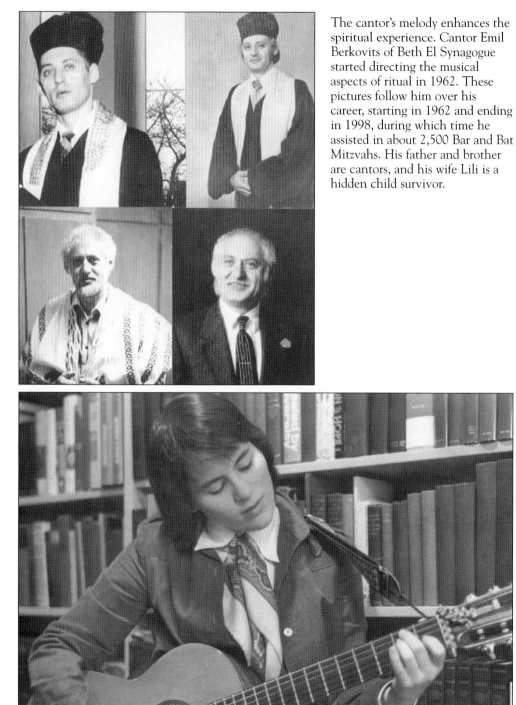

The cantor's melody enhances the spiritual experience. Cantor Emil Berkovits of Beth El Synagogue started directing the musical aspects of ritual in 1962. These pictures follow him over his career, starting in 1962 and ending in 1998, during which time he assisted in about 2,500 Bar and Bat Mitzvahs. His father and brother are cantors, and his wife Lili is a hidden child survivor.

Musical tastes, styles, and personnel change periodically. The Civil Rights movement was followed by the expansion of women's claims to equality in employment, compensation, and participation in religious ritual. The Reform movement was the first branch of Judaism to graduate women as rabbis and cantors, followed soon after by the Conservative movement, though not without dissension. Here Cantor Gail P. Karp, then of Temple Israel, practices on the guitar.

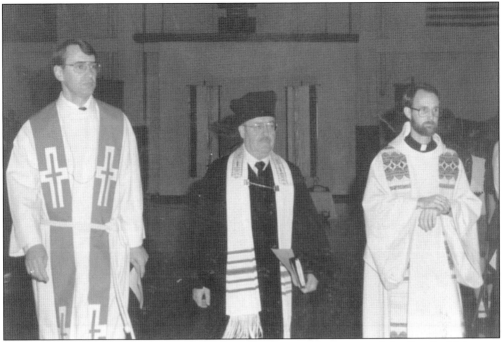

Cantor Leo Fettman of Beth Israel, a Holocaust survivor and organizer of the Omaha Holocaust Survivor's Society, recorded his experiences in *Shoah: Journey from the Ashes* (1999). He travels the state giving presentations to the Christian community. Here he is pictured in an ecumenical service with Rev. Merton Fish, Director of Pastoral Care at Immanuel Lutheran Medical Center, and Rev. Jim Schimelpfenning, S.M., Director of Campus Ministry, Gross High School.

Traditionally women did not achieve top leadership in the synagogue or Federation. Nonetheless, women are vital as the expression, "A woman of valor who can find? Her price is far above rubies" suggests. Synagogue activities such as Sisterhood or Women's League, Hadassah, National Council of Jewish Women, Pioneer Women, and other women's organizations created a sphere for female leadership. Temple Israel has hired women rabbis and cantors.

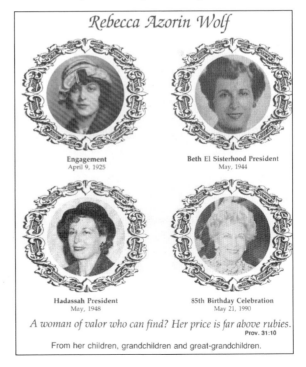

Rebecca Azorin Wolf

Engagement
April 9, 1925

Beth El Sisterhood President
May, 1944

Hadassah President
May, 1948

85th Birthday Celebration
May 21, 1990

A woman of valor who can find? Her price is far above rubies.
Prov. 31:10

From her children, grandchildren and great-grandchildren.

The Jewish Press

Vol. XLVII—1 Second Class Postage Paid at Omaha, Neb. New Year's Edition — Rosh Hashanah 5729 Monday, September 23, 1968 Publication Office, 101 No. 20th St. Omaha, Neb. 68102, Phone 312-1366 Annual Rate 4 Dollars Single Copy 10 Cents

'And he shall turn the heart of the fathers to the children, and the heart of the children to their fathers.

Malachi 3:24

About This Issue: 'Telling It Like It Is'

The weekly *Omaha Jewish Press*, founded in 1920, always printed a large New Year's issue, containing Rabbi's messages, annual synagogue, communal organization, and club reports, running over 80 pages. Starting in the 1960s, a special edition for Rosh Hashanah and later Passover contained unifying themes, usually historical, such as youth, grandparents, women, sports, education, health, aging, Central High School, the Old Market, 50th, 75th and 100th anniversaries of major organizations, the Jewish Community Center, anniversaries of events like the founding of Israel, and commissions writers for applicable stories. Several issues have won national awards. As a weekly it tends to announce upcoming events, and promote public relations, rather than report news, though it carries a wide range of wire service reportage of Jewish interest. The editors have journalism and public relations backgrounds. At various times there were specific sections for Des Moines, Sioux City, Council Bluffs, and Lincoln. The arrival of the *Jewish Press* in the Friday mail set a tone for Shabbat, and if it arrives on Saturday, the Press office gets complaints.

32

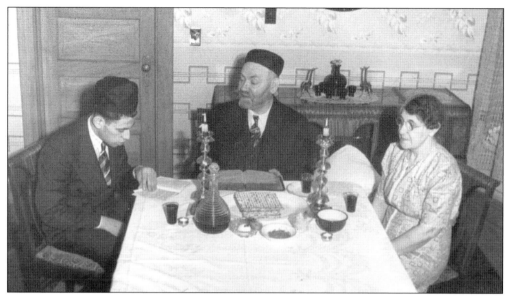

This early 1930s Seder includes Nathan Shukert and his parents, Jacob and Miriam. Jacob came from Poland in 1907, worked in a South Omaha packing house, and opened his own meat market about 1917. Nathan operated Shukerts Kosher Butchers until retirement in 1980. His son Martin was Omaha City Planning Director from 1983 to 1988. His wife Aveva, a Brandeis University graduate, is a practicing psychologist.

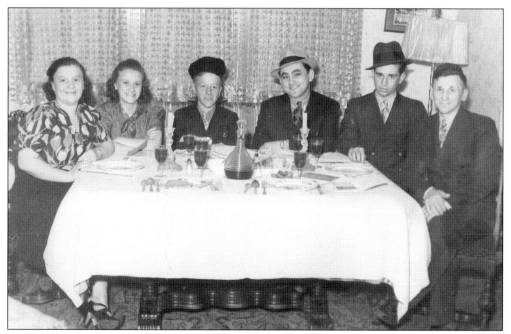

The Passover or Pesach, and the Hagaddah, relate the story of Moses leading the Jews out of Egypt, God's relationship to the Jews, and freedom. The ritual meal for family, friends, and newcomers may last three to five hours including commentary, questioning and discussion, and song. A separate place is set for the prophet Elija. This is Mrs. William, Betty, Eddie, Norman, unidentified, and William Kuklin in the 1940s.

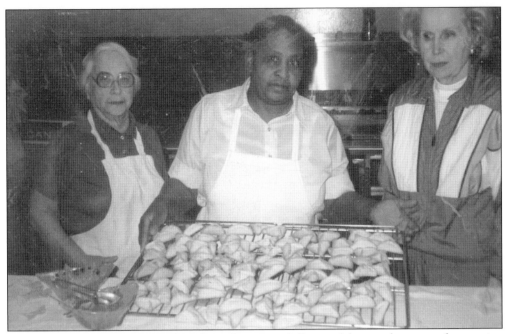

Nothing's as tasty as Hamentashen from the oven. A Purim delicacy, these mouth watering and addictive three sided morsels are filled with poppy seed, peach, or raspberry jam. Here they are being baked by Mary Fellman, co-founder of the Nebraska Jewish Historical Society and dedicated community organizer, the much loved Lucy White, who has been cooking at Beth El Synagogue since 1964, and Etta Epstein. Purim has a carnival atmosphere.

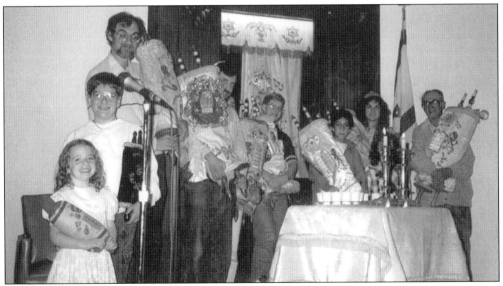

In the late 1980s, B'nai Israel Synagogue in Council Bluff's, Iowa, was rejuvenated with young Jews. This 1991 picture includes the Rosenberg and Kurland families and "Doc" Jerome Bleicher celebrating Simchat Torah. The congregation split in the mid 1990s, and Beyt Shalom, a Reconstructionist congregation, moved to Omaha and holds services at the Unitarian Church building on 119th Street. They have an active religious education program and periodically employ a student rabbi.

34

Education lies at the soul of Jewish life. Consecration in kindergarten, Bar or Bat Mitzvah at the age of 13, and Confirmation are the major milestones in Jewish education. Requirements and ritual differ between Orthodox, Conservative, and Reform. This picture of Orthodox practice from January, 1907, shows Abe Abrams putting on *tefillin* on his Bar Mitzvah.

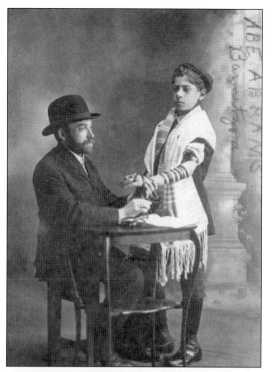

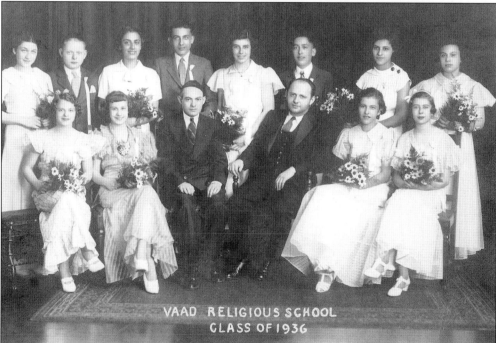

This picture of the Vaad Religious School, Class of 1936, contains in the back row, Beverly Babendure, Harold Nesselson, Rosaline Baum, Max Cohen, Charlotte Flesh, Leonard Morgenstein, Shirley Chasen, and Bernice Crounse. The front row contains Helen Minken Finkel, Helen Fogel, Haskell Cohen, Rabbi H.A. Berger, Ruth Miller, and Labrina Herzoff.

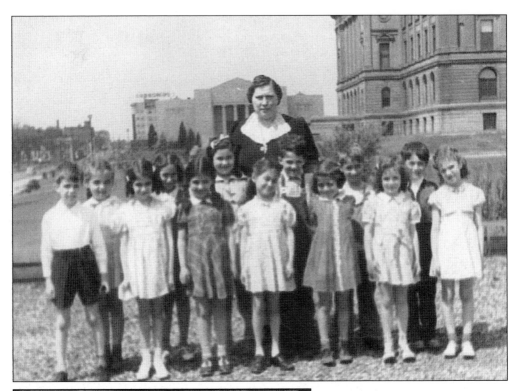

CITY TALMUD TORAH
OMAHA, NEBRASKA

The Board of Education
hereby awards

The Honor Sign

וועד החנוך
נותן
את ציון הכבוד

ת"ת

To the Pupil _____

in recognition of the *Excellent* Grades received in all the subjects

during the Season of _____

CHAIRMAN—BOARD OF EDUCATION PRINCIPAL
 TEACHER

This picture of a Sunday School class on the roof of the Jewish Community Center at Twentieth and Dodge was taken in May 1941. In the background is Joslyn Museum designed by John MacDonald and opened in 1931. The Joslyn contains a small collection of silver Jewish ritual objects. On the right is the corner of Omaha Central High School attended by most of Omaha's Jewish youth.

Report cards and teacher conferences may be welcome or dreaded. But certificates and diplomas are treasured mementos of educational milestones. This City Talmud Torah award for "Excellent" was presented to Shalom Kaplan in 1927. Translation courtesy of Leo Greenbaum, Central High and Omaha University graduate, Archivist at YIVO Archives, New York.

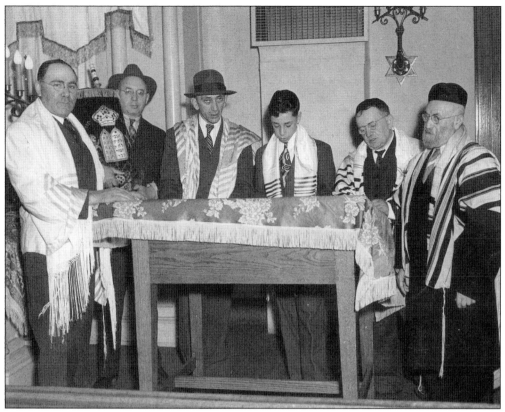

Pictured is Jerry Rosinsky's Bar Mitzvah at the South Omaha Synagogue in 1944. At the Bimah the Bar Mitzvah reads from the Torah accompanied by Cantor Mendel Sellz, Harry Dworsky, Sam Rosinsky, Jerry Rosinsky, Mr. Wolfson (the teacher), and Abe Epstein. The photograph of his brother, Richard, at the Bimah for his Bar Mitzvah in 1940, is almost identical. Photographs of events taking place in synagogue on the Sabbath were generally posed at an earlier time.

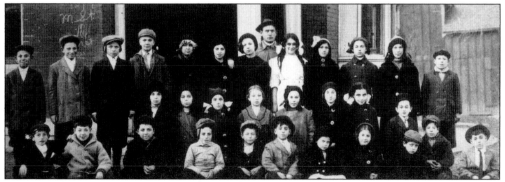

The terms Talmud, Torah, and Cheder prevailed among Yiddish speaking immigrants. The term Hebrew School prevailed after 1950. Classes usually met after 4 p.m. on weekdays and on the weekend. This is the Tifereth Israel Hebrew School in Lincoln in 1917. Mr. Weber, the teacher, stands with his 30 students, about equally divided between girls and boys.

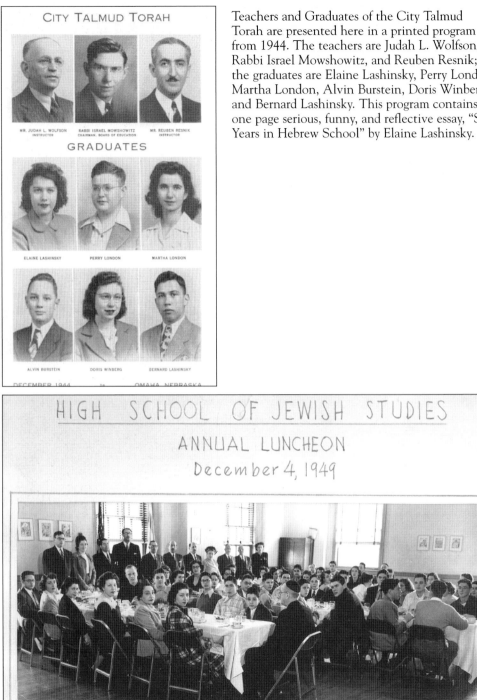

CITY TALMUD TORAH

MR. JUDAH L. WOLFSON
INSTRUCTOR

RABBI ISRAEL MOWSHOWITZ
CHAIRMAN, BOARD OF EDUCATION

MR. REUBEN RESNIK
INSTRUCTOR

GRADUATES

ELAINE LASHINSKY

PERRY LONDON

MARTHA LONDON

ALVIN BURSTEIN

DORIS WINBERG

BERNARD LASHINSKY

DECEMBER 1944

OMAHA NEBRASKA

Teachers and Graduates of the City Talmud Torah are presented here in a printed program from 1944. The teachers are Judah L. Wolfson, Rabbi Israel Mowshowitz, and Reuben Resnik; the graduates are Elaine Lashinsky, Perry London, Martha London, Alvin Burstein, Doris Winberg, and Bernard Lashinsky. This program contains a one page serious, funny, and reflective essay, "Six Years in Hebrew School" by Elaine Lashinsky.

HIGH SCHOOL OF JEWISH STUDIES
ANNUAL LUNCHEON
December 4, 1949

The High School of Jewish Studies maintained a scrapbook in 1949. This picture of the annual luncheon in December 1949 indicates the names of religious leadership conducting the program, Rabbis Silberman, Kripke, and Mossman, and medical doctors Gelbart, Margolin, and Sher, as well as other lay leaders committed to religious education.

Bar Mitzvahs, like weddings, frequently are accompanied by celebration. On Friday night there is a dinner for out-of-town guests. Large Bar Mitzvahs will fill the parking lot and sanctuary, with guests coming from as many as 15 states, Canada, South America, and Israel. On Saturday night there is a party, as depicted in this picture from 1950, celebrating the Bas Mitzvah of Suzie Richards.

Beth El, Conservative synagogue, started to have women on the Bimah, and give 13 year old girls Bat or Bas Mitzvah. In this picture are Morris Fellman, his daughter Marsha Fellman (Zimmerman) holding the Torah, and Cantor Aaron Edgar, at her Bat Mitzvah in November 1961. The Sisterhood was renamed Women's League in the early 1990s. In the Conservative movement women read regularly from the Torah.

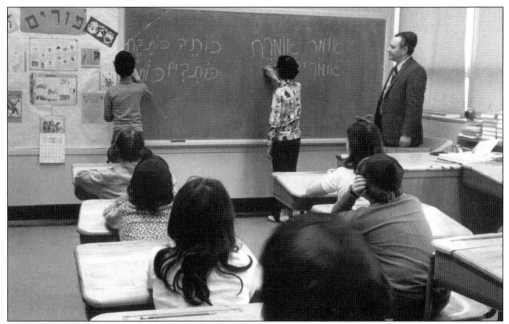

Classroom facilities, teaching techniques, and electronic technology have no doubt improved the teaching and learning process. Nothing, however, has replaced the rudiments of learning the Hebrew alphabet and the chalk blackboard. Here Hebrew teacher Walter Feidman observes his students at Beth El. Hebrew and Yiddish are also taught periodically to adults at the Jewish Community Center.

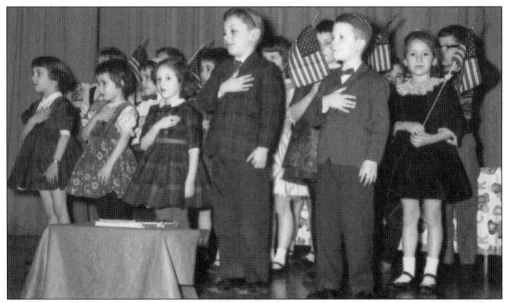

The establishment of a Jewish Day school in Omaha lagged behind other cities, probably because the number of parent's desiring such facilities were limited, and the local public school was considered of good quality. The Omaha Hebrew Academy opened in 1961, and these children were students there. By the 1970s, arrangements had been made with a Montessori school where a group of Jewish students could also receive religious instruction.

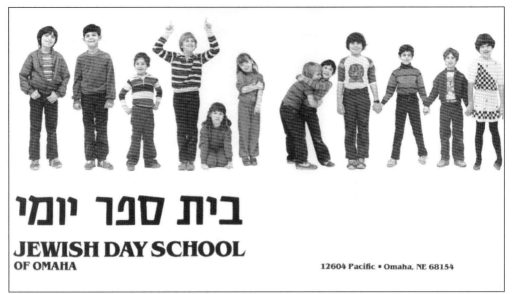

בית ספר יומי
JEWISH DAY SCHOOL
OF OMAHA

12604 Pacific • Omaha, NE 68154

A Jewish Day School providing Jewish and secular education from kindergarten to sixth grade opened in 1974. Endowed by Leonard Freidel in 1986, it was renamed the Friedel Academy. In 1995 it moved into the Dan and Esther Gordman Center for Jewish Learning at the Jewish Community Center. During the 1990s, the annual enrollment was about 30 students. Some orthodox families send their children to Yeshivas in Memphis and St. Louis.

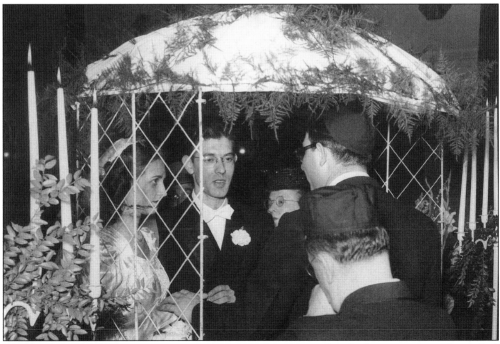

Weddings and wedding anniversaries are intimately associated with the synagogue. The *aufruff* precedes the wedding. The wedding involves a decorated *chupa* (canopy), the *ketubah* (Hebrew inscribed marriage certificate) and the groom breaking the glass. This picture depicts the marriage of Helen Handler and Ben Rifkin at the Paxton Hotel in March 1948.

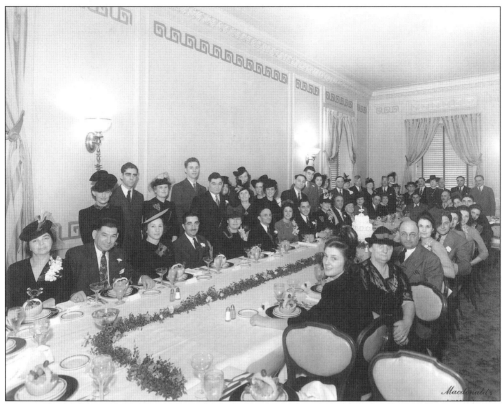

This is the wedding meal for guests at the betrothal of Selma Hill and Bob Cohen on September 26, 1941, in Lincoln. They were members of Tifereth Israel. They moved to Denver and pursued scrap metal recycling. Having Bar mitzvahs in Israel and splendiferous weddings were signs of devotion and having made it in America.

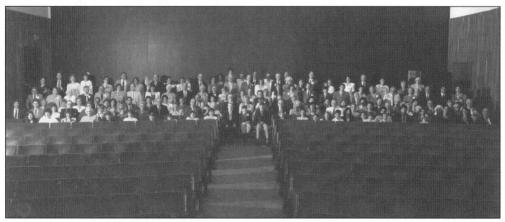

Family, friends, food, and philanthropy combine at celebrations and reunions for milestone birthdays and silver and golden wedding anniversaries. They validate religious commandments and public policy sanctifying monogamy and fidelity. "No gifts please—We suggest a donation to your favorite charity." This picture taken at Temple Israel on June 17, 1989, celebrates the Kulakofsky family's 100 years in Omaha.

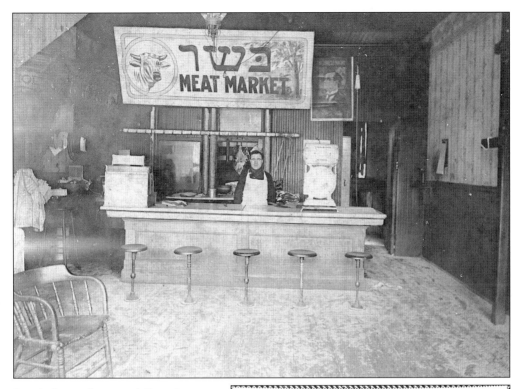

Jewish dietary laws are followed stringently by Orthodox Jews and many Conservative Jews. Cattle, sheep, and chickens must be slaughtered in a particular manner under the supervision of a rabbi. The year 1881 marks the arrival of the first permanent *schochet*. This is a 1913 picture of the kosher meat market owned by Mushkin and Epstein at 1415 N. Twenty-Fourth Street.

Seen here is an advertisement for Kosher meat at Cofelt's from October 16, 1931. Other merchandising included the distribution of Hebrew Almanacs containing the time of sunrise and sunset, provided by United Kosher Sausage Co., similar to the provision over the years of the Passover Hagaddah by Maxwell House Coffee and Kosher cookbook pamphlets by the B. Manischewitz Co. By the 1930s, Omaha had about seven kosher meat markets.

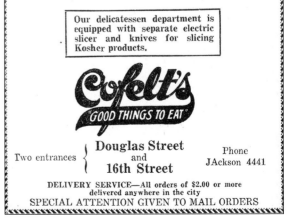

WE ARE

HEADQUARTERS FOR
Strictly Kosher SAUSAGES and MEATS

Manufactured by the KOSHER STAR Sausage Mfg. Co.
Chicago, Illinois

BEEF FRYE, Bacon Style, 1-2 lb. pkgs. 20c
Frankfurters, Knockwurst, Weiners, lb. 30c
Salami, square or round, lb.39c
Bologna, thick or regular, lb.29c
Sliced Cooked Corn Beef, lb.89c
Pastroma, lb87c

> Our delicatessen department is equipped with separate electric slicer and knives for slicing Kosher products.

Cofelt's
"GOOD THINGS TO EAT"

Two entrances { **Douglas Street** and **16th Street** } Phone JAckson 4441

DELIVERY SERVICE—All orders of $2.00 or more delivered anywhere in the city
SPECIAL ATTENTION GIVEN TO MAIL ORDERS

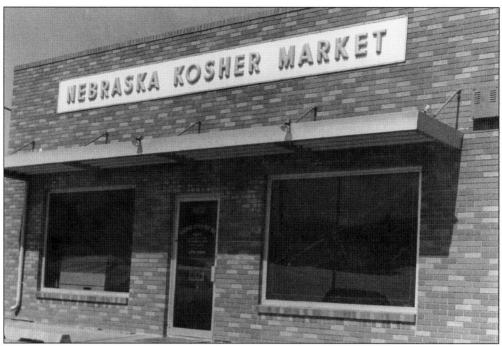

Joseph Bucheister and his wife Freda, Holocaust survivors, operated Nebraska Kosher Meat Market until 1992. There is insufficient demand to support a kosher meat store. Leon Shrago, owner of Bag'n Save, and an Orthodox Jew, is a major supplier of Omaha's kosher needs and Passover Seder tables. Locally produced kosher bagels reappeared in 1978 at the Bagel Bin.

Jewish burial disfavors cremation. Establishing a cemetery separate from the general community was an early priority. The first Jewish cemetery in Omaha was established in 1871 at Pleasant Hill at Forty-Second and Redick. There are several Jewish cemeteries in Nebraska including Mount Sinai Cemetery in Hastings, established in 1886. This is an architectural sketch of Omaha's Ike Friedman Jewish Funeral Home.

Three

POLITICIANS AND PUBLIC SERVICE

THE JEWISH ROLE IN THE LARGER COMMUNITY

Jewish men and women have played a prominent role in public life serving as mayors, councilmen, state senators, and United States senators. In the judiciary they have filled the seats on County, District Court, and Appellate benches, as well as serving as justices and chief justices of the state Supreme Court. They serve as university chancellors. In local affairs they have been instrumental in creating the Community Chest, the forerunner to the United Way, a citywide organization addressing economic, housing, health, and mental health welfare. Nebraska is unique among the 50 states in that since 1937 it has had a single chamber legislature, the Unicameral. The urban eastern part of the state tends to be Democrats of moderate ilk while the agricultural West is Republican.

Loyalty to America has been a main theme, from naming a B'nai B'rith Lodge after the assassinated President William McKinley, to the litany of Fourth of July speeches. Linking American patriotism and commitment to Israel is second nature. Jews distinguished themselves as officers and enlisted ranks in World Wars I and II, Korea, and Vietnam, and the Jewish War Veterans have been an active group.

Omaha Jews have achieved peak leadership positions in national and international organizations that bring them into consultation with United States presidents, the United Nations, and Israeli officials. There is a distinct consciousness on the part of Omaha Jewish leaders to overcome isolation and avoid a parochial outlook by staying in tune with national and international movements.

Edward Rosewater (1841–1906), born in Bohemia, was a telegraph operator during the American Civil War. He came to Omaha in 1863 to manage transcontinental telegraph services. A correspondent for several newspapers, he started the *Omaha Bee* newspaper in 1871, was very influential on the Omaha school board, and ran unsuccessfully for the United States Senate. This postcard shows the Bee Building adjacent to City Hall and the Court House. An elementary school was named for him.

CITY HALL AND BEE BUILDING, OMAHA, NEB.

The First World War and the increased risks in crossing the Atlantic effectively curtailed Jewish immigration to America. The United States entered the war in 1917. Many Omaha Jews enlisted in the Army and Navy. Here Private Abe Bear (1900–65) salutes proudly. However, the editors of the Omaha *Jewish Bulletin* opened an office in Omaha to advise conscientious objectors. Omahans sent aid to Jewish war victims and orphans in Europe.

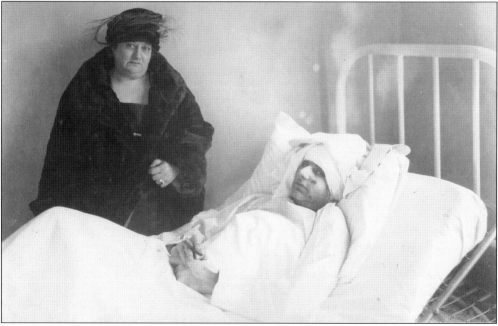

Ben Danbaum's family came to Omaha in 1869. He was chief of detectives in the Omaha Police Department. In December 1924 he was shot while making an arrest. His mother, Mary Goldman Danbaum, is at his hospital bed. This photograph comes from a picture album entitled, "The Shooting of Dan McGrew." He retired to Florida and went into the wholesale liquor distribution business.

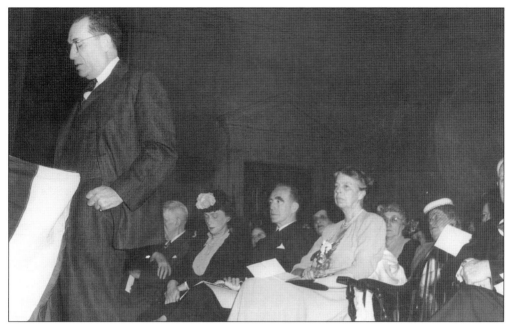

Henry Monsky (1890–1947) earned his law degree at Creighton University in 1912, joined B'nai B'rith, and by 1938 was president and spokesperson for the world's largest Jewish organization. He conferred with President Roosevelt and Truman on Jewish issues, Naziism, the war, Holocaust, United Nations, and the creation of the State of Israel. Eleanor Roosevelt is sitting behind Monsky as he gives a speech in New York in May 1944.

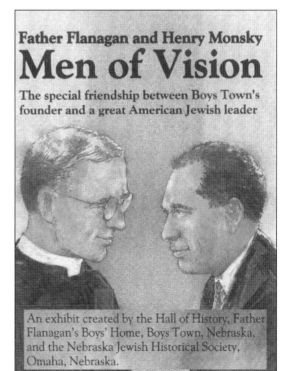

Father Flanagan and Henry Monsky

Men of Vision

The special friendship between Boys Town's founder and a great American Jewish leader

An exhibit created by the Hall of History, Father Flanagan's Boys' Home, Boys Town, Nebraska, and the Nebraska Jewish Historical Society, Omaha, Nebraska.

Henry Monsky and Father Edward Joseph Flanagan (1886–1948) from Ireland, who created Boys Town, shared a common vision. Monsky provided some of the early funding to create Boys Town and was attorney for the project. Monsky is depicted as a businessman in the 1938 film *Boys Town*. This brochure accompanied a traveling exhibition on Catholic-Jewish relations mirrored in the career of these two men.

Ruth Diamond (Levinson), born in McCook, went to the University of Nebraska. President of the Municipal University of Omaha, William Sealock hired her in 1932 to teach Physical Education and dance. In April 1941, she choreographed "Dictatorship," a parody of Hitler at the Joslyn Museum featuring Ahuva Gershater, pictured here in "Mocking a Dictator." During the war, Ruth worked for the Red Cross. (Courtesy of University of Nebraska at Omaha Archives.)

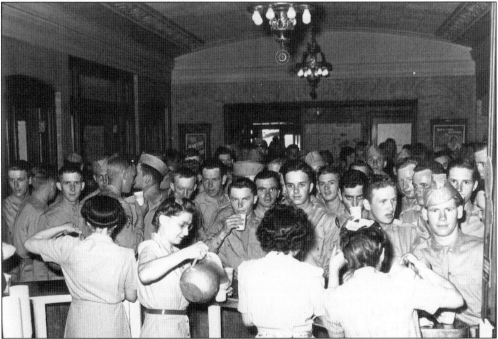

Offutt Air Force Base, other military bases in the region, and the Union Pacific Railroad passing through the city meant a steady presence of young GIs. The USO provided hospitality. YANKS (Youth Army Navy Committee for Service) operated a canteen at the Jewish Community Center. Rabbis were stationed at Strategic Air Command and its successor Stratcom. (Courtesy of John Savage Photography Collection, Durham Western Heritage Museum.)

Bond drives raised substantial funds for the war effort. B'nai B'rith was nationally recognized for its patriotic financial efforts. Movie stars crisscrossed the country drumming up voluntary and patriotic financial support for the war. Special airplanes, tanks, ambulances, and jeeps were identified as the result of particular bond drives to promote further investment.

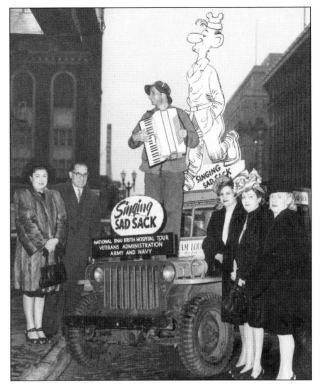

Communications between servicemen to their families in America were subject to censorship and called V[ictory] Mail. Private Abraham Baum writes in January 1944 to his parents in Omaha, Mr. and Mrs. Max Baum, how the Jewish Community Center is sending news to servicemen. Another postcard from "Somewhere in England" expresses that the censors cannot stop the news that "I love you."

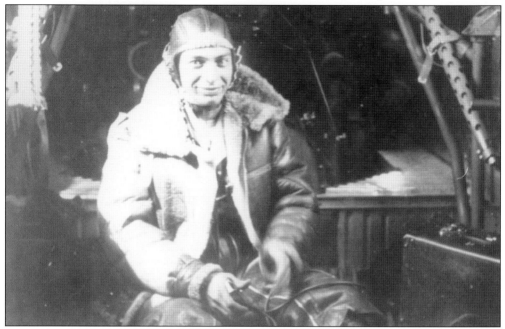

The Neiden family settled in Lincoln in 1909. Max Neiden, an air force technical sergeant, is seen here in a B25. Stationed in England, he participated in the Berlin Airlift. Neiden Iron and Metal, a three generation business, was sold in 1999.

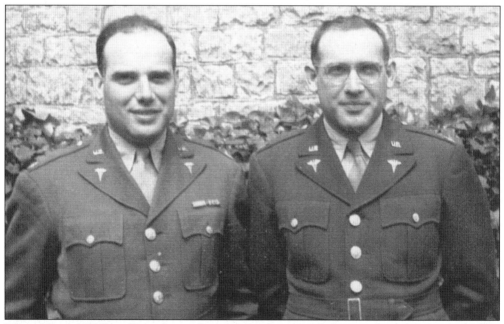

Edward E. and William Rosenbaum, born in Omaha, earned their medical degrees in the late 1930s. They served in France, Germany, and Austria, at Normandy and Dachau. The location of Allied units being secret, they met only by chance in England in 1944 where this picture was taken. They both moved to Portland and practiced medicine. Edward got cancer. His *A Taste of My Own Medicine* was made into a film, *The Doctor* (1991), starring William Hurt.

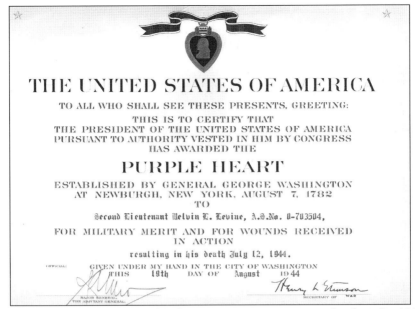

THE UNITED STATES OF AMERICA

TO ALL WHO SHALL SEE THESE PRESENTS, GREETING:

THIS IS TO CERTIFY THAT
THE PRESIDENT OF THE UNITED STATES OF AMERICA
PURSUANT TO AUTHORITY VESTED IN HIM BY CONGRESS
HAS AWARDED THE

PURPLE HEART

ESTABLISHED BY GENERAL GEORGE WASHINGTON
AT NEWBURGH, NEW YORK, AUGUST 7, 1782
TO

Second Lieutenant Melvin L. Levine, A.S.No. 0-703504,

FOR MILITARY MERIT AND FOR WOUNDS RECEIVED
IN ACTION

resulting in his death July 12, 1944.

GIVEN UNDER MY HAND IN THE CITY OF WASHINGTON
THIS 19th DAY OF August 1944

The ultimate sacrifice, giving one's life for one's country, is memorialized in the 1945 *Jewish Press* New Year edition listing 16 dead. This Purple Heart Citation records the death of Milton Levine in 1944. The *Jewish Press* announced his engagement in January 1944 stating "no definite date has been set for the wedding." Hymie Epstein, killed in 1942 in New Guinea, was nominated unsuccessfully for a Congressional Medal of Honor in 1975. Our debt to ordinary brave men and women defending our country is enormous.

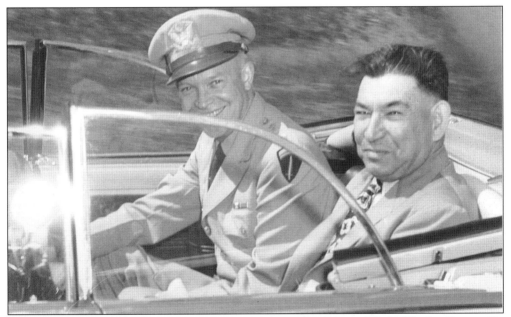

Nathan Grossman, born in Lithuania in 1894, fought in the Army in World War I in France. He had clothing stores in Lincoln, was devoted to ex-servicemen's affairs, and very active in Lincoln's Jewish organizations. During World War II, he worked at the USO building. His wife Celia was active in Jewish affairs. In this 1946 picture, he is riding with General Dwight David Eisenhower.

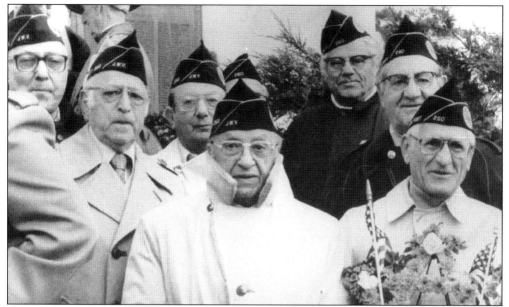

Jewish War Veterans assembled for Memorial Day and Veterans Day, the latter depicted here in November 1983 at Memorial Park, erected to honor World War II Veterans, and the *latka* party they give at Chanukah. In the back row are Don Strauss, Keith Peltz, Bill Pachman, Yale Halperin, Nate Marcus, and Dr. Milton Margolin. In the front are Sol Lagman and Sol Mann. There was an Epstein Lodge Ladies Auxiliary.

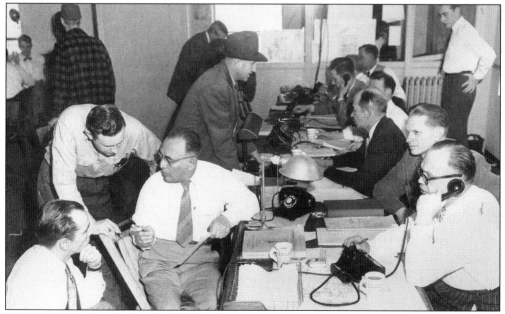

During the Missouri River Flood of April 1952 college students assisted in filling sandbags to create levees to contain the Missouri River. Harry Trustin, sitting on the left, is in a white shirt and tie. He fought in the First World War in France. An engineer, he belonged to many Jewish and non-Jewish organizations, like the Urban League. He ran for City Council on the slogan, "Trust in Trustin." Here he is helping direct efforts against the rising river.

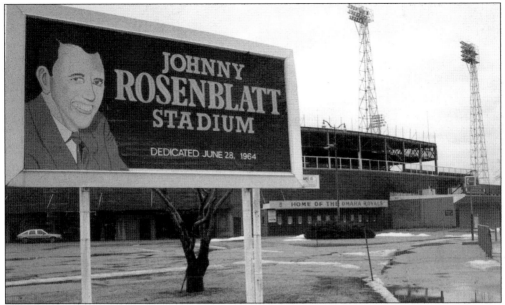

Johnny Rosenblatt, the second Jewish mayor of Omaha, served from 1954 to 1961. The first Jewish mayor, more accurately, acting mayor, was Harry B. Zimman in 1905. Rosenblatt was an avid baseball player, and Omaha's baseball stadium is named after him. This field was home to the Omaha Royals and Omaha Golden Spikes, a Triple A team in the Kansas City Royals' organization. Rosenblatt Stadium hosts the College World Series.

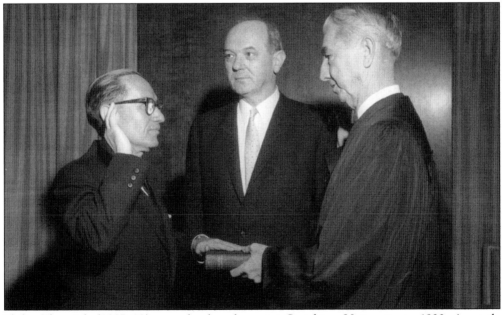

Philip Klutznick (1907–99) earned a law degree at Creighton University in 1930. An early advisor of B'nai B'rith's AZA, he became president of B'nai B'rith International. He directed the Federal Public Housing Authority during the war and pioneered Chicago's suburban development. Supreme Court Justice Tom C. Clark swears Klutznick in as a United Nations delegate with Secretary of State Dean Rusk as witness. Klutznick was Jimmy Carter's Secretary of Commerce.

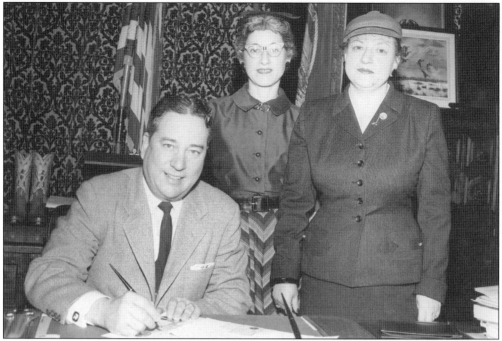

Republican Governor Victor Anderson in March 1956 is being presented a leather bound Israel Stamp book by Lincoln Hadassah members Mrs. Lester Goldman and Mrs. Nathan Bernstein on World Jewish Child's Day. In another picture Democratic Governor Ralph G. Brooks presents in March 1961 the Nebraska Flag to Mrs. Simon Galter, Mrs. Leo Hill, Mrs. Goldman, and Mrs. Bernstein, on the dedication of Hadassah's medical center in Jerusalem.

A delegation from Beth Israel synagogue, Alvin Ross, lawyer and insurance agent; Jane Cohen, wife of owner of Mayfair Fabrics; and Rabbi Isaac Nadoff of Beth Israel Synagogue, watch Nebraska Republican Governor Norbert T. Tieman (1967–71) sign a declaration regarding Israel Independence Day. In two other pictures Democratic Governors Frank Morrison in 1961 and J. James Exon sign proclamations for Hadassah.

54

Here are Richard Fellman, Congressman Dan Glickman from Kansas and later Secretary of Agriculture, Peter Hoagland and John Cavanaugh, both Nebraska Democrat Congressmen (1989–95, 1977–81). Fellman, a graduate of Central High, University of Nebraska, and Nebraska Law School served as County Commissioner, State Senator, and ran as a Democrat for Congress in 1966, 1980, and 1982. Richard's wife Beverly, a long time French teacher, helped organize Central High's 2001 centennial celebration.

Milton and Pauline Abrahams were very generous. Milton's family arrived in Omaha in 1866. He earned his law degree at Creighton University and met his wife, an accomplished artist, at a B'nai B'rith convention in Milwaukee. He served as president of Temple Israel and the Jewish Federation of Omaha. He was a member of the Douglas County Library Board and a library is named in his honor.

Sarah Z. Rosenberg, executive director of the Nebraska Committee for the Humanities (1982–87), the state agency of the National Endowment for the Humanities, traveled the state bringing the humanities to out-of-school adults. Here she is with Gov. Bob Kerrey in the Capitol Rotunda. Her husband Norman has been associated with the University of Nebraska and the Washington foundation Resources for the Future. (Courtesy of the Nebraska Humanities Council.)

EDDIE
SHAFTON
OMAHA PRESS CLUB'S
LEGAL EAGLE
MARCH 21, 1991

LEGAL STORM

LEGAL
PIT-
FALLS

LEGAL
HOT
WATER

LAW

The Omaha Press Club in 1991 honored Eddie Shafton with the "Face on the Bar Room Floor." Shafton, a lawyer interested in local housing and issues concerning youth, is humorously lauded. Fresh out of law school Shafton was a defense lawyer in the 1932 Prohibition era trial of City Boss Tom Dennison. Shafton, confidante of Omaha Mayor A. V. Sorenson, 1965–69, was appointed to the very powerful Personnel Board.

This photograph from October 1979 includes Jan Schneiderman who would later serve as National President of National Council of Jewish Women, 1999–2002; Edward Zorinsky, Mayor of Omaha, 1973–76, and United States Senator from 1976 until his death in 1987 at 59 from a heart attack while performing in an Omaha Press Club review; and his wife Cece. The Zorinsky family had a tobacco and candy vending machine business. A federal building and a park are named after him.

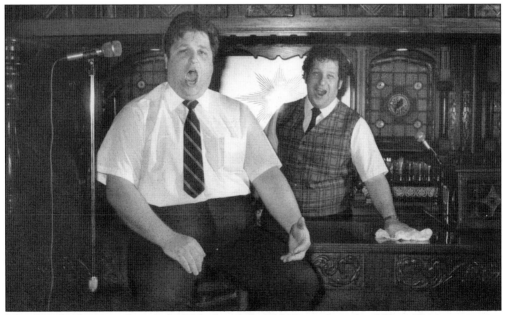

The Anti-Defamation League (ADL), founded in 1913 as a branch of B'nai B'rith, maintains its Plains States office in Omaha. Attorney Robert Wolfson, director since 1988, has contact with community leaders and the media placing him in the forefront of Jewish civil rights and combating anti-Semitism. Here he belts out a song with his brother Douglas. Another brother, Ronald, is vice president of the University of Judaism in Los Angeles.

Ally Milder, a graduate of the University of Nebraska at Omaha and Creighton University Law School, served as Chief Counsel to the Senate Judiciary Sub Committee. She ran as a Republican for Congress in 1990, and was elected to the Nebraska State Board of Education in 1992. Political pamphlets for Jewish candidates start with Edward Rosewater's 1906 bid for the United States Senate.

The University of Nebraska has had three Jewish chancellors. Joseph Soshnik held that office from 1968 to 1971. Graham Spanier, 1991–95, became president of Pennsylvania State University. Pictured here is Harvey Perlman, born in York, Nebraska. He joined the College of Law faculty in 1967, became Dean in 1983, Interim Chancellor in 2000, and formally appointed to the leadership of the University in 2001 as the 19th chancellor. (Courtesy of the University of Nebraska.)

Four

THE BUSINESS OF MAKING A LIVING
FROM PEDDLERS TO SUBURBAN DEVELOPERS
AND TELEMARKETERS

The American physical and economic frontier beckoned Jewish adventurers and entrepreneurs. They graduate from peddlers, backpacks, or selling cigars, to hand pushed barrows and horse drawn carts into under-served and marginal markets, and opened grocery and dry-goods stores in small towns and city neighborhoods. Technological change and entertainment drew them to the mass produced and competitively priced ready-to-wear clothing industry, theater, and motion pictures. An eye to recycling paper, metal, cloth, and rubber, and very low capital investment business drew them to establish scrap and salvage yards along the rail line.

In Omaha and Lincoln, mom and pop grocery, butcher, and hardware stores were neighborhood fixtures. The Brandeis department store in Omaha and Golds in Lincoln became fixtures of high style and sophisticated shopping offering a wide variety of consumer choices. They flourished for several years to be eclipsed by national supermarket chains, and department stores of regional and national scale.

The children of the immigrant generation had a wide variety of career choices, with law and medicine being most prominent followed by teaching and corporate employment. No family owned business has yet gone into the fifth generation. A new niche, real estate development, covered land acquisition, construction, management, and sale of the completed project.

Not all Jews were capitalists. There were many peddlers. A small and vocal community of labor held a Socialist vision. The Arbeter Ring or Workmen's Circle was active until the 1950s. The ranks of the left were thinned by age and children's upward mobility into the business world, but a certain Yiddishkeit, compassion for the less fortunate, survived.

Julius Meyer opened the Indian Wigwam, a curio shop and museum that attracted many tourists. Meyer learned several Indian dialects. He closed the Wigwam in 1880. In 1883, he went to Paris for three months with a group of Omaha and Winnebago Indians. He was active in the Congregation of Israel choir (Temple Israel) and died under mysterious circumstances in Omaha in 1909. (Courtesy of Nebraska State Historical Society.)

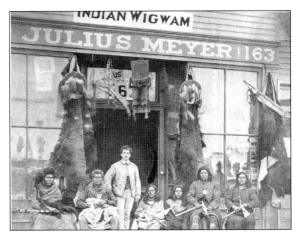

1316 -- VICTORIOUS! -- 1316

JUST AS WE TOLD YOU.

We have been telling you we would try the experiment of GIVING GOODS AT LOW PRICES TO MAKE BUSINESS BOOM. We've done so to your, as well as our own, satisfaction, the increase of our business the past season over all others, and the headway we are making with all classes of people, show us that when we advertise bargains in Custom Made Clothing, the people are quick to take advantage of our offer.

JUST RECEIVED.

Latest style and elegant made garments, made and trimmed in the best manner, which are open for your inspection. All alterations to insure a perfect fit, free of charge.

POLACK, THE CLOTHIER,

1316 Farnam Street, Near Fourteenth, 1316.

Seen here is an advertisement from 1885. Alexander Polack, clothier, came to Omaha from Baltimore in 1866. Jews gravitated into the new, used, readymade clothing, and alterations businesses. The first Jewish owned business, May and Weil, outfitters for ready made clothing, footwear, hats, blankets, and guns in Omaha and Council Bluffs, dates from 1855. In 1856, Meyer, Hellman, and Aaron Cahn opened a wholesale and retail clothing store. By 1870, about half of Omaha's 15 clothing stores were Jewish owned.

SOL BRODKEY,
JEWELER AND
DIAMOND BROKER

——— GO TO ———
...Eagle Loan Office...
FOR LOANS ON
Diamonds, Watches, Jewelry, Guns,
Musical Instruments, Etc.

Best Accomodations in the City.
Business Confidential.
Remember the Number.

1301 DOUGLAS ST., OMAHA, NEB

Seen here is a 1907 advertisement. Next to this advertisement was an announcement of the availability of religious books and articles such as *talaisim, tefillin, mezuzot,* and skull caps (*yamilkas, kippas*), a trade that has devolved into the synagogue gift shop.

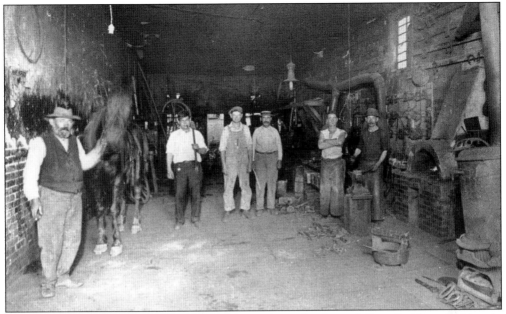

Ike Shev's Blacksmith shop around the corner from the Journal Star Building in Lincoln about 1910 evokes an age of buggy whips and horse drawn carriages. Pictured here are Israel Schuchman, Charley Grossman, Morris Aronson, Mose Poska, an unidentified helper, and Ike Shev. Before the automobile, horse-drawn wagons delivered coal, ice, and feed for horses.

The garment industry, ready made clothes, tailoring (*schneiders*), clothing stores, and *schmatas* (rags) are synonymous with Jewish enterprise. Maypers Clothing and Furniture, Goldstein-Chapmans, Reliable Clothing, Herzbergs, P. Crandell Furrier, Natelson's, Nebraska Clothing Company, Tully's Men's Store, Ben Shafton's clothing and shoes, Friedman's Shoe Repairing, Zalkin Peerless Wiping Cloth Co., and Jack Cohen's Mayfair Fabrics are some of the more familiar names.

Clothing Stores that survive include Ben Simon and Son in Omaha and Lincoln, and Wolf Brothers Western Store, in its fourth generation of family ownership moved from downtown to near Seventy-Second and Dodge in 1963. Landon's Clothing left downtown for a suburban strip mall. Nebraska Clothing Store reopened in the Old Market after a several decade hiatus

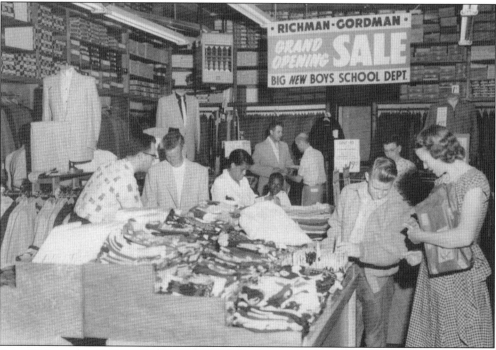

Sam Richman and Dan Gordman started Richman-Gordman clothing store in 1915. It expanded to 15 moderately priced department stores in Omaha, Lincoln, Des Moines, Grand Island, Topeka, and Kansas City. They started the 1/2 Price Store in 1972 and expanded to 36 stores in nine Midwestern states. Managed by the fourth generation, it was renamed Gordmans in 1999. This is the second store, at Twenty-Fifth and L about 1950.

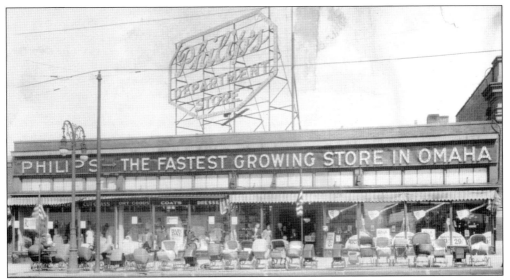

In South Omaha the Philips Store was a landmark. Founded by Philip Greenberg, it expanded under the management of his sons, Henry and Sam. Sam, a graduate of South High School, was affectionately called "Mr. South Omaha." The store, started in 1908, extended credit to customers during the Depression. It closed in 1987, as changes in retailing and demographics, and building of a freeway made it uncompetitive with larger chain stores.

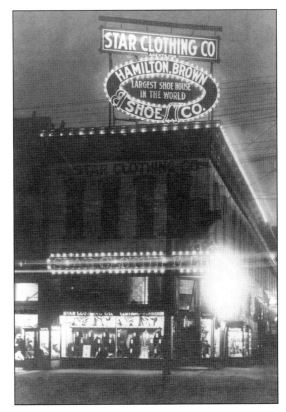

The Nefsky family arrived in Lincoln from Russia in 1882. They went to a Jewish agricultural colony in South Dakota, and after locusts, drought, and a cyclone, "failed at farming," and returned to Lincoln in 1887. They had a succession of businesses including used furniture, Star Clothing and Guarantee Clothing, which went out of business in 1987. Robert Nefsky, an attorney, has been active in the Nebraska Humanities Council.

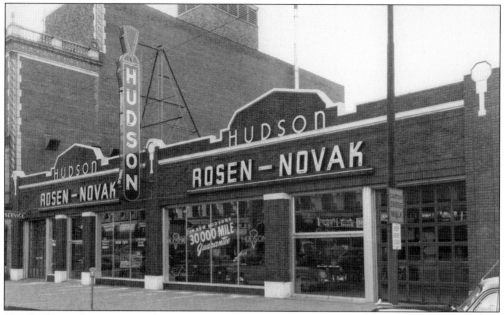

Car dealers and gas stations changed the urban landscape. Edward Rosen and Ben Novak started a car dealership in Nebraska City and expanded to several locations in Omaha. They handled the Hudson until it merged with Packard in 1954, Cadillacs, and several other General Motors and European models. They closed the dealership in 1986. The last downtown dealership is the site of a square block Salvation Army Rehabilitation Center.

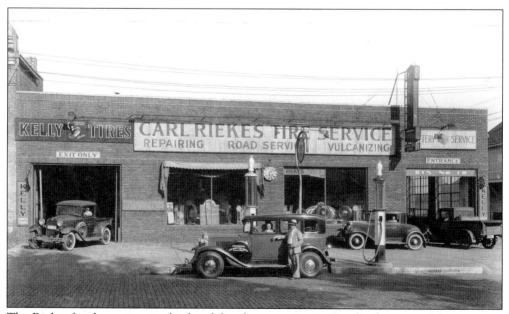

The Riekes family, now in its third and fourth generation in Omaha, has moved from tires to the container industry, Riekes Crystal giftware, and the practice of the law. Always generous, they have supported, through personal effort and money, the preservation of Jewish culture through the B'nai B'rith, the synagogue, Jewish Community Center, Jewish Federation, and endowed the Henry and Dorothy Riekes Museum of the Nebraska Jewish Historical Society.

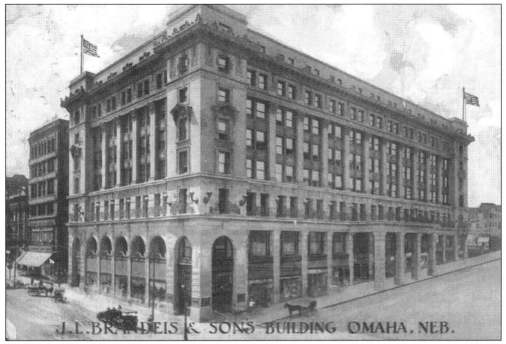

The major retailer in Omaha was Brandeis, established in the 1880s and initially called the Boston Store. Its eight-story downtown store at Sixteenth and Douglas contained a restaurant and theatre across the street. Brandeis expanded to eight suburban locations including Lincoln. New and expanding retailers such as Younkers and Dillard's prompted a strategic sale of Brandeis in 1987 to Younkers and the downtown store's conversion to office space.

William Gold was born in New York in 1864, moved to Iowa, and then Sutton, Nebraska. He moved to Lincoln in 1902 and within a short time opened the People's Store, a popular merchandising name at the time. They had 5,000 square feet and 16 employees. They soon called themselves "Lincoln's busy store." (Courtesy of the Nebraska State Historical Society.)

The Gold's business grew to 350,000 square feet and over 1,000 employees with an additional 100,000 square feet for parking. This is the block long building during its 50th anniversary in 1953. In 1964 it was sold to J.L. Brandeis of Omaha and then to Younkers. Today Gold's Galleria houses small shops and offices. (Courtesy of the Nebraska State Historical Society.)

Harry H. Lapidus owned the Omaha Fixture & Supply Co. He was very active in B'nai B'rith and a major fundraiser for the Cleveland Orphan's Home and the Denver Consumptive Hospital. He was murdered in a gangland style slaying. Some say he was too close to the gang, others suggest that he was in league with Federal authorities to expose local corruption.

Nebraska Furniture Mart, Allen Furniture, and Davidson's Furniture, in the fourth generation in Omaha and Lincoln, showing remarkable staying power, are still in business today. The most famous, Nebraska Furniture Mart, was started in 1938 by Russian immigrant Rose Blumkin with very little capital. Rose was an active salesperson when she was 100 years old, riding around the carpet department in a golf cart. She died in 1998 at the age of 104.

Warren Buffett and Berkshire Hathaway purchased 90 percent of Nebraska Furniture Mart in 1983 for $55 million. In 2001, Berkshire Hathaway announced that a second larger location would open in Kansas City. Berkshire Hathaway purchased another major Jewish retailer, Borsheim's, the Tiffany's of the Midwest, a jewelry store started by Louis Friedman and expanded by his son Ike. Like Nebraska Furniture Mart it has a dominating marketing presence in the region.

Mastercraft Furniture was founded by Meilach Katzman in 1924. It has 110 employees and has been at its near northside location since 1942. It produces upper end furniture for the Midwest market. It is now run by the third generation, Mike and Rick Katzman, both active in Beth Israel and Federation. Carol Katzman, wife of Michael, has been the Omaha *Jewish Press* editor since 1996.

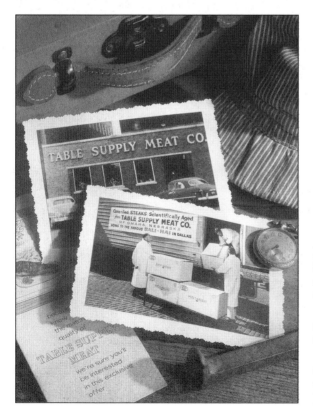

Nebraska is noted for its steaks. J.J. Simon left Riga, Latvia, in 1890 and started with his son, B.A. Simon, the Table Supply Meat Co. in 1917. Now in its fourth generation of family ownership it is called Omaha Steaks International, has 1,800 employees, and ships choice cuts of frozen meat around the world. (Courtesy of Omaha Steaks International.)

Morris Jacobs (1895–1987) helped establish and run the weekly Omaha Jewish Press in the early 1920s. He went into partnership with Leo Bozell in 1923 creating Bozell and Jacobs, a major international advertising and public relations firm that by 1962 had offices in 13 states. Here he is presented in a "Ripley's Believe It or Not" feature appearing in many newspapers.

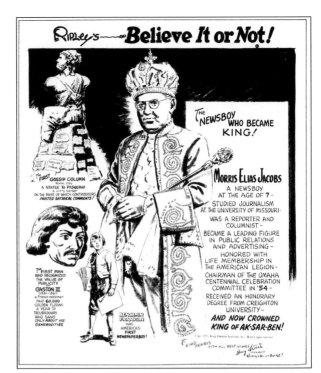

Phil Schrager founded Pacesetter Corporation in 1962. It manufacturers windows, doors, cabinets, flooring, siding, and other products for the home. Located in southwest Omaha, it employs over 2,000 people nationwide. Brother Harley joined the business in 1972. Phil maintains a noteworthy collection of modern art that adorns the exterior of the factory and his home. The brothers have been very generous in Jewish and cultural affairs.

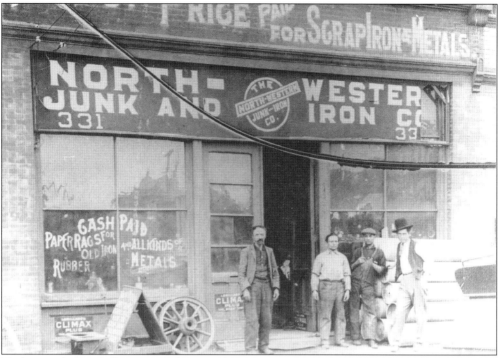

Nathan and Dan Hill ran Lincoln's North-Western Junk and Iron Co. Aaron Ferer started Omaha's Ferer Metals on the Missouri River and was bought by Asarco. Norfolk and Hastings had Jewish scrap dealers. The latter dealing in scrap iron, metals, rags, bones, and old rubbers, wrote in 1906 in Yiddish to the Industrial Removal Office to sponsor newly arrived Jews. Omahan A.B. Alpirn in 1905 dealt in "old railroad material."

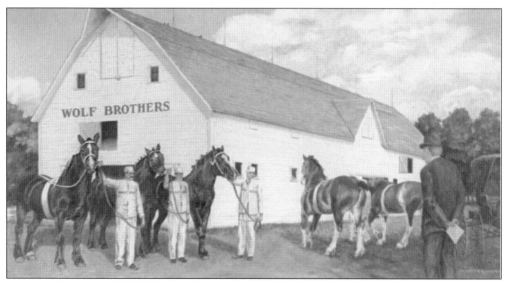

Jim Wolf (1921–) earned a law degree at Harvard, was president of Albion National Bank, and owns an active cattle ranch in Albion in Boone County. Wolf Brothers runs a major cattle feed lot operation. Jim Wolf ran unsuccessfully for the State Unicameral and is very active in the Anti-Defamation League.

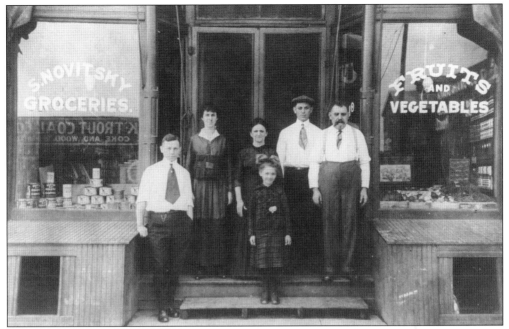

Before refrigerators and freezers, shoppers walked to neighborhood markets, purchased meat, fish, vegetables, and baked goods and carried them home. Pictured in front of S. Novitksy grocery at 1010 N. Sixteenth Street about 1915 are Ben Novitsky, Sarah Novitsky Feltman, Sophie, Sol and Sam Novitsky, and Leone Novitsky Stein, all related to Lois Friedman, an NCJW president, and a founder and first treasurer of the Nebraska Jewish Historical Society.

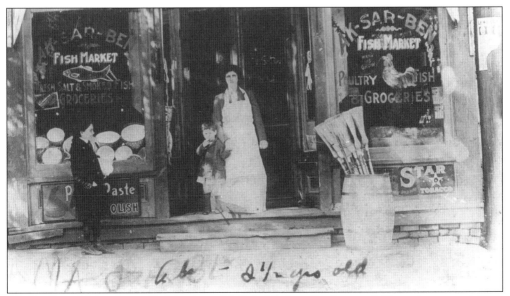

Ak-Sar-Ben (Nebraska spelled backwards) Fish Market, Poultry, and Groceries around 1919 was owned by the Faier family. Ak-Sar-Ben, a fictional romantic kingdom, was also the name of the major charitable society in Omaha, which holds a debutante ball, complete with a college-age queen and an older king. There was almost always one Jewish boy and girl in the entourage, and sometimes established Jewish community-minded businessmen have served as a king.

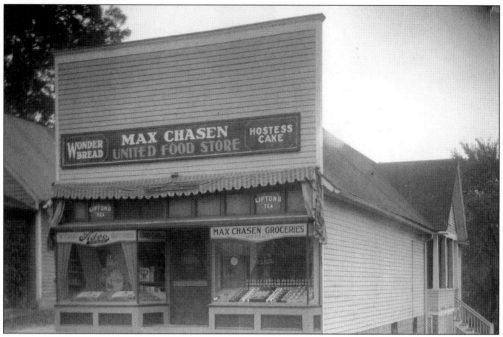

Max Chasen's United Food Store around 1933 at Thirtieth and Chicago Streets. Wonder Bread, Hostess Cake, Post Toasties, Jello, Liptons Tea, Advo, Butternut, and Hills Brothers Coffee were trusted household names. Pickle barrels, tongue, liver, and herring are just a few of the fading ethnic foods.

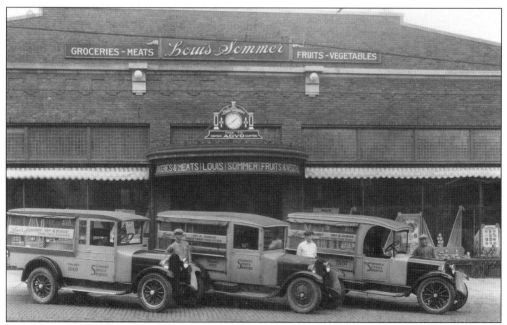

Louis Sommer opened his market at Forty-Eighth and Dodge Streets in 1910. The Sommer family came to Omaha from Hungary in 1883. All the Sommer men entered the grocery business. The Kulakofsky family owned the Central Market located at Sixteenth and Harney Streets.

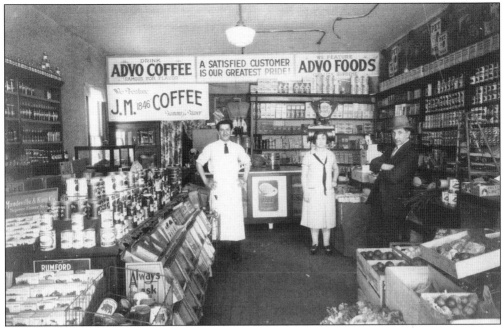

Sam's Food Market at Sixteenth and William was owned and operated by Sam and Eva Lebowitz during the 1930s. During the 1950s, Uncle's Sam's Market, owned by the Siporins, at 1404 N. 24th, was advertised as "The Store where your mother's grandmothers bought good food. You too can buy here with confidence."

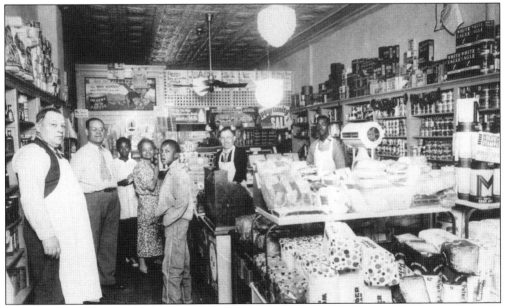

This is the Federal Market owned by Kiva Hornstein and Sam Siporin at 1414 N. 24th Street. The picture from about 1940 includes Sam Siporin, Mr. Gitlin, a neighbor who owned a clothing store, three customers, Kiva Hornstein, and an employee. What had been a Jewish neighborhood around 24th Street, as in many American cities, became a predominantly African-American neighborhood.

Harry Rubenstein, a wholesaler, had offices in Omaha and Lincoln. This is Hymie Milder's order for $61.94 in May 1941. The wholesale food market for retailers and restaurants was downtown in the Market District near railroad facilities. Trucking, refrigeration, frozen foods, and consumer buying habits dramatically changed the structure of the wholesale and retail industry. Kirschbraun & Sons was a major national supplier of butter and eggs.

Unless a mom and pop shop could establish a special presence in the community, like Albert Wohlner's Wohlners Grocery or Louis Paperny's Louis Supermarket and Bar, they would be eclipsed by the automobile and the supermarket. Abe Baker started Bakers in 1928 as a locally owned multi-location Omaha supermarket chain. Still called Bakers, it was purchased in the 1990s by Fleming Foods, and by Krogers in 2001.

Hinky Dinky started in 1925. Allegedly the name came from "Hinky dinky parlez vous," lyrics from a song that was popular during World War I. Owned by the Newman family it expanded to several state-of-the-art supermarkets. Like A&P (Atlantic and Pacific) and Safeway, it ultimately could not keep its market share in the face of major national food retailers like Albertson's, Cub Foods, and Hy Vee.

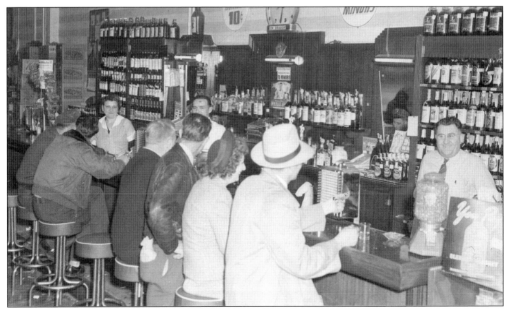

Jews owned bars, liquor stores, and wholesale liquor distributors. Ben and Fannie Abrahamson are shown here in a picture taken about 1965 in their South Omaha Liquor Mart. A major retail establishment, Spirit World, started by Dennis Lewis in 1973, had two locations. Two out of five local wholesale distributors, United Distillers and Nebraska Wine and Spirits, are Jewish owned.

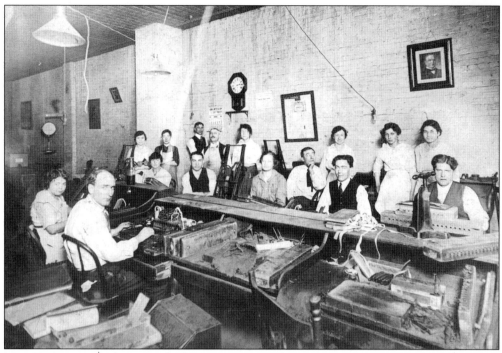

Max Kushner arrived in Lincoln from Russia via New York in 1913, proceeded by his uncle and brother. He worked in Pepperberg's Cigar Factory at Ninth and O. He married Dorothy Zabolsky, a Galveston immigrant. He started a grocery store called Kushner's Little Big Store, which his sons expanded to four Kushner groceries in Lincoln. Other Kushner ventures included a variety store and pawnshop. (Courtesy of Sheldon Kushner.)

Nathan Yaffe opened a print shop in Omaha and soon bought out his partner William Castleman. The print shop with Yiddish and Hebrew type did printing for Jews in Omaha, Lincoln, and Sioux City, including Bar Mitzvah and wedding invitations and Yiddish broadsides. Yaffe printed the shortlived *Western Jewish Journal* in 1909, of which no copies appear to have survived. Yaffe's sons, Sol and Irv, ran the business until the 1980s.

Robert Smith --- Gentleman

BY K. MAXIM.

It was while investigating a certain case before the Insanity Commission, some time ago, that the writer had the pleasure and privilege of coming in contact with the subject of this sketch under conditions which revealed those qualities of the man which have made for his wonderful success and popularity.

The writer expected the Clerk of the District Court to be like a great many others are, the type of man who will lend himself to be the political tool of some faction or Big Boss, through whom corporate interests or other "interests" effect jury-bribing and all the other evils of "invisible government."

Imagine our surprise to find a polished "gentleman," refined, tactful, learned, an expert in the work of the Insanity Commission, one who has personally handled over 2500 cases which have come before the Board in the time of his office, with that niceness and finnesse which the sad circumstances of such cases require—the sparing of the feelings of the sufferers as well as the sufferers' friends. We were astounded with the fount of his experience and information. The manner in which he touched upon the various cases under discussion, showed the human kindness of the man, his deeply religious nature, his broad and tolerant views, his deep sympathy with human frailty.—God's suffering children.

And it was from contact in this department of his Official duties, that we came to learn of his many good works in the service of the people, which we take particular pleasure in presenting to our readers, in reproof of the accepted fallacy that a politician must be bad: for, here is a politician, and it has never been our pleasure to meet a finer man, nor one who is a worthier example, for the emulation of our youth!

Coming into office nine years ago, he found that there had sprung up an organized graft in the matter of cashing the jury-warrants. It seems that our county is always behind in the matter of finances, and that when the citizens had given their time on the jury, and received their warrants on the treasury, there were no funds to pay them, and that jurymen had to wait months—as high as six, and nine, and even a year!—before the exchequer was sufficiently filled to pay the amounts! Many of these men were poor, and needed the money, and so certain favored ones bought up these warrants, at a reduction, of course, and later cashed them in at par!

If a corporation was being tried, for some offence against an individual, or, against the people it served, it had only to "demand" that a "right" jury be sworn in, and of course it is evident in whose favor the verdict was rendered.

During the nine years Robert Smith has served as Clerk of the District Court, not even his bitterest enemy can accuse him successfully of a single instance of lack of faithfulness to his duties to his office, or lapse of justice and righteousness in their full performance!

It was Robert Smith who drafted the Election Commissioners' Law which made it impossible for the Gang or the Big Boss to corrupt the elections. We who have large experience in fraternal societies, know that very often our candidate is defeated because the opposition has the power to elect the tellers!

And Robert Smith it was who helped to defeat the new City Charter whereby the Gang in Control could control the Judges and Clerks of Election. Those of you who are familiar with Tammany Hall Rule, and the manner in which a Democratic minority in New York City, and other cities, through corrupt practices and inefficient laws, corruptly misapplied, retain the reign of government, appreciate what the preservation for the people of the power of honest elections means!

Robert Smith is an advocate in Efficiency, as produced by better wages, and the copyists in his office have received, and are receiving, 50 per cent more pay than before his coming to office! And that he is tolerant and wholly unprejudiced, is proven in that all nationalities are represented on his payroll, and that a Jewish young lady has held the choicest position for a long time.

And his is not a job-creating bureau, as so many political offices are, sad to say, due to the spoils system! He has paid over to the county treasurer $81,000 more than his predecessor in a similar period of time, which moneys have been saved to the taxpayers of this county, through the honesty, the integrity, the efficiency, the right-man-for-the-right-place kind of service, which is the coin in which Robert Smith has paid for the confidence reposed in him by his supporters.

And what dwells mostly in the writer's mind, and what strengthens our friendship for Robert Smith, the man, is that he is a student, an honest, progressive student, of the woe and the problems of Israel.

civic ideals, of just reward to duty nobly done, we ask our citizen readers to return to the office he has so loyally and efficiently graced for nine years, at this coming election, November, the seventh, the one most fit to hold it and discharge its important duties—Robert Smith, gentleman!

Maxim and Isaac Konecky from New York published the lively, colorful, and controversial weekly *Jewish Bulletin* from 1916 to 1920. Most copies have not survived and the microfilm only starts in 1919. This page was recently found in the family records of Laurie Smith Camp, granddaughter of Robert Smith, the subject of the center column story. The Koneckys published articles about Jewish husbands deserting their wives and children, divorce, what they thought were shady business practices, and generally washed dirty laundry in public. They gave publicity to the activities of various peddler and scrap dealer unions, as well as other Jews on the fringe of the established Jewish community. The editors attacked the Omaha Jewish establishment and the B'nai B'rith, comparing it to an elitist conspiracy. The *Jewish Press* was founded in 1920 by about 20 prominent community leaders to provide a more respectable Jewish voice and put the *Bulletin* out of business by diverting advertising, which it did. (Courtesy of Laurie Smith Camp.)

This bill from Max Rosenstein written in Yiddish is to "attach gas fixtures." Translation from Yiddish is courtesy of Leo Greenbaum, archivist at YIVO in New York. Many East European Jews were small proprietors or laborers working at South Omaha slaughterhouses, smelters, on the railroad, as painters, plasterers, peddlers, carpenters, barbers, confectioners, plumbers, locksmiths, and laborers.

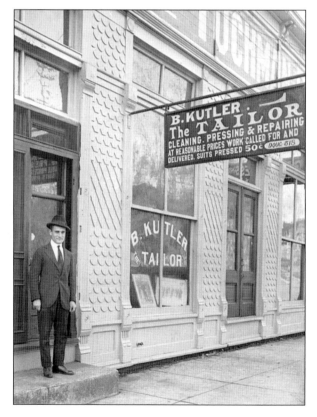

The Tailor's shop was north of Nineteenth and Dodge. In 1940, Carl and Michael Lewis, at Twenty-Ninth and Farnam, charged 35¢ to press a suit. Small tailor shops hung on by a thread. Like many grocery stores, the owner's family lived above or behind the shop. Dry cleaners, such as Marcus Cleaners at 1943 Vinton Street, were another aspect of the clothing trade.

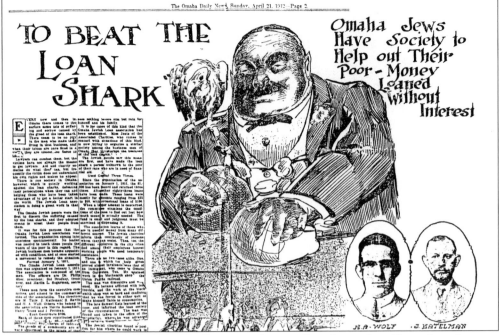

Jewish communal self-help was very effective in keeping Jewish social problems from the view of the larger community and for providing the wherewithal for financial betterment. Many cities established Hebrew or Jewish Free Loan Societies. This newspaper story from *The Omaha Daily News*, Sunday, April 21, 1912, is positive publicity of Jewish money lending. Loans were granted in confidence to respect the recipient's privacy.

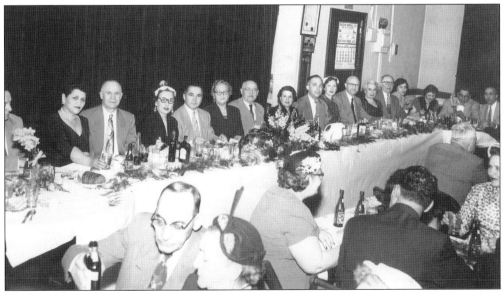

Jewish or Hebrew Free Loan societies were part of the communal infrastructure. Some workers established publicized loan clubs, offering members low interest loans. This helped many small businesses get a start and stay afloat, including the Blumkin family's early financing of Nebraska Furniture Mart. Here the Workmen's Loan is celebrating 30 years of operation.

79

The Workmen's Circle, the Arbeter Ring, established in New York in 1892 reached Omaha in 1907. The secular and socialist atmosphere of the Labor Lyceum distinguished it from the JCC and synagogue. This Lyceum built in 1922 at Twenty-Second and Clark moved to Thirty-First and Cuming Street in 1940. Sam Lerner, second on the left, recruited members in Sioux City, Lincoln, and Des Moines.

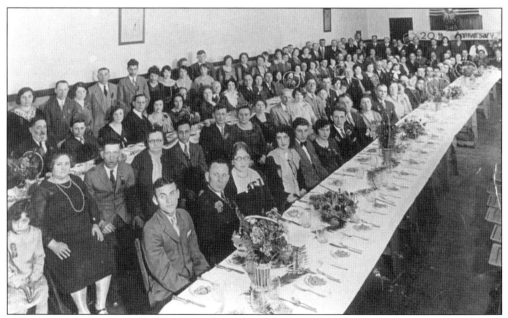

Arbeter Ring #348 in Lincoln is celebrating its 20th anniversary at a banquet in the Tifereth Israel Social Hall. Delegates from Omaha branches traveled the 50 miles, and congratulatory messages and flowers were sent from New York and other Midwestern branches. The WC offered life insurance and other insurance benefits. The immigrant generation was not very successful in inculcating their children into becoming members as adults.

Mr. and Mrs. Ben Gerelick, Louis Paperny, Z. Kaplan, Sam Canar, Nathan Martin, S. Tarnoff, A. Feldman, unidentified, and Nearenberg celebrate the 45th anniversary of the Workmen's Circle Branch 258 in 1952 at the Labor Lyceum located on the east side of Adas Jeshuran Synagogue on Cuming Street.

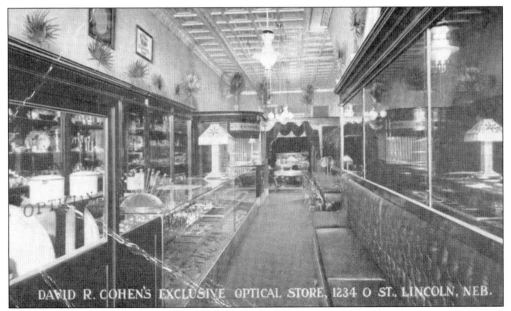

Jews played a prominent role in optical manufacturing and dispensing as opticians and opthalmologists in Omaha and Lincoln. This postcard of David R. Cohen's Exclusive Optical Store in Lincoln dates from 1909. Prominent optical suppliers in Omaha were Malashocks and Commercial Optical. Jewish compassion for the vision impaired has an extensive history, including volunteering in braille programs and Radio Talking Book. (Courtesy of Nebraska State Historical Society.)

Dr. Milton and Ann Margolin take a holiday on The Love Boat (the name of a 1970s television comedy series). William Friedlander, physician and historian, taught medical humanities for several years at the University of Nebraska Medical Center. The embryonic stem cell research on behalf of neurodegeneration by Dr. Howard Gendelman, an Orthodox Jew, attracted international recognition and the opposition of the Right to Life movement.

Construction steel manufacturer Phil Sokolof suffered a near-fatal heart attack at 43. He became America's leading anticholesterol activist, spending $14 million of his private funds waging war against high-fat foods. His national advertising campaigns forced McDonald's and the industry to remove beef tallow from fries, forced food processors to eliminate coconut and palm oils, and lowered the fat in school lunches. He was Honorary Co-Sponsor of legislation providing "Nutrition Facts" food labels.

Five

YOUTH
GROWING UP JEWISH

Parents, synagogues, and communal organizations hoped their Jewish children would socialize with and marry other Jews. In the early 20th century, intermarriage referred to an Orthodox Jew marrying a Reform Jew. By mid-century it meant a Jew marrying a Christian. By the end of the century it might refer to marriage between a Jew and an Asian. The open society challenged long-held beliefs and values of the parents and led to substantial social, educational, and religious investment to foster Jews marrying Jews. Houses of worship and the Jewish Community Center were the front line. Nonetheless, the open American society, social and economic mobility, and curiosity led to choices that conflicted with parental and communal expectations. Nowhere was this more dramatically presented than in Al Jolson's 1927 film The Jazz Singer.

Omaha was not an Eastern European shtetl nor a metropolis like New York or Chicago with neighborhoods where Jews comprised a majority. High school and college, school and after school, and social and sport activities enriched the individual's education, competitive instincts, and exposure to a variety of life choices. To combat the liberating effect of upward mobility and the decline of discipline and adherence to tradition, community leaders hired professionals to mentor teenage development, promoted Jewish summer camps, and youth missions to Israel. They made a major investment to reinforce community self-preservation. By the end of the 20th century the norm was for Jewish youth to earn their college degrees outside Nebraska and settle down in Chicago, Atlanta, Denver, St. Louis, San Francisco, Kansas City, or Boston.

Posed and candid pictures of children abound. Pictures of Sophie, Yale, Max, and Ethel Halperin taken by an itinerant Goat Cart Photographer in South Omaha in 1922. A similar picture from 1922 containing Mandolfo, Fisher, Domet, Merritt, and three Piccolo children is in *Omaha, Times Remembered* (1999). For an interesting film about an English mid-19th century Jewish female photographer, see *The Governess* starring Minnie Driver (1998).

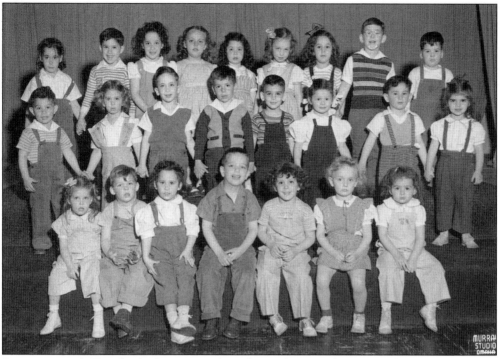

Synagogue and Temple facilities were heavily used on Fridays, Saturdays, Sundays, and weekday evenings for congregational activities. The spacious facilities with kitchens were used on alternate days for additional income by the development of ecumenical nursery schools and pre-schools which assisted working mothers who left their children in a safe and caring environment. This is the Beth El Synagogue Nursery School class in 1945.

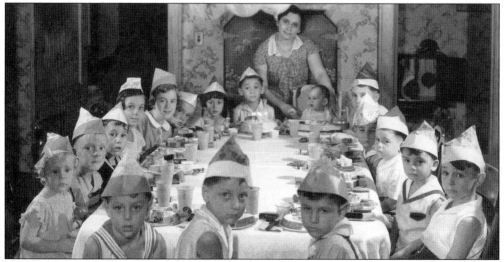

Family, school, neighborhood, and synagogue friends gather for birthday parties, ice cream, cake, gifts, and prizes. Seen here is Donald Vann's party in the early 1930s. This is before plastics, and the punch or lemonade is in dixie cups, lightly waxed and waterproof. In addition to the festivities note the wallpaper, wood trim, and electric light button switch on the left and the telephone on the right.

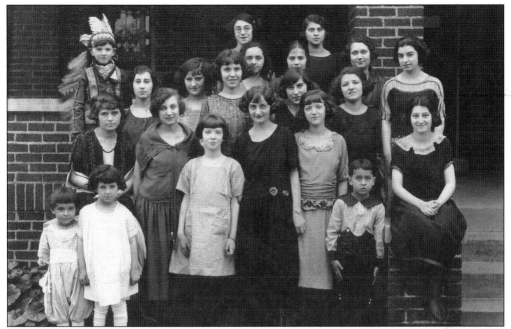

Seen here is Ida Lustgarten's 16th birthday in May 1923. The Lustgarten's liked birthday parties. Dorothy's seventh birthday in December 1919, received front page coverage in the *Jewish Bulletin*. Their father, Ben Lustgarten, left Russia, worked on his brother's North Platte farm, and earned enough money to bring his wife Pola to America. His son Steven started practicing law in 1960, and his grandson Michael in 1988.

Summer camp, getting children out of the city and into the countryside for fresh air and mosquitoes, was a middle class mantra. They went to B'nai B'rith Camp Beber, Conservative movement Camp Ramah, and Camp Hertzl, all in Wisconsin, and to the JCC Camp closer to home. This picture is from 1956. The cabin name, "ga-a-vek," is Yiddish for "go away."

The Jewish community started supporting camping in 1931. Camp Esther K. Newman near the Platte River operated as a summer camp and retreat. An entire generation of Omaha Jewish youngsters attended during its period of operation from 1961 to 1978. It was sold to Nebraska Parks and Game and became part of Louisville Recreation Area.

"Uncle" Chuck Arnold was the towering 6 foot 6 inch director of the JCC athletic program from 1962 to 1989. He played defensive tackle for the University of Alabama Crimson Tide under coach Bear Bryant, 1958–1962. Through humor, he often motivated children, adults, and senior citizens to exercise. This picture was taken in Kiddie Camp, 1966.

Young Men's Hebrew Association formed in Omaha, like the YMCA, offered a wide range of social, literary, and athletic programs. Basketball was considered a Jewish sport. The 1924 team included Coach Harry Kneeter, Sam Liebowitz, Red Rees, Max Altshuler, Ben Goldware, Sam Ban, Meyer Green, Schneider, and Coach Phil Mandel.

Before radio, affordable sound recordings, talking films, or television, entertainment and amusement were live and amateur. Here the YMHA Cantata Group in 1917, like the many choirs and barbershop quartets, reflect participatory group activity before the electronic age.

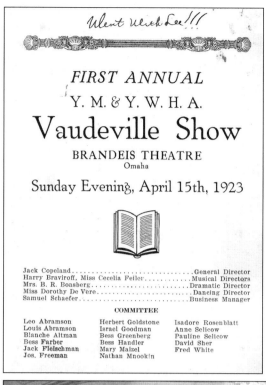

Went with Lee!!!

FIRST ANNUAL
Y. M. & Y. W. H. A.
Vaudeville Show
BRANDEIS THEATRE
Omaha

Sunday Evening, April 15th, 1923

Jack Copeland...........................General Director
Harry Braviroff, Miss Cecelia Feiler...........Musical Directors
Mrs. B. R. Boasberg......................Dramatic Director
Miss Dorothy De Vere.....................Dancing Director
Samuel Schaefer.........................Business Manager

COMMITTEE

Leo Abramson	Herbert Goldstone	Isadore Rosenblatt
Louis Abramson	Israel Goodman	Anne Selicow
Blanche Altman	Bess Greenberg	Pauline Selicow
Bess Farber	Bess Handler	David Sher
Jack Fleischman	Mary Maizel	Fred White
Jos. Freeman	Nathan Mnookin	

The YM and YWHA First Annual Vaudeville Show program in 1923 was performed at the Brandeis Theatre. It comes from Celia Gidinsky's richly packed "School Friendship Book" for the period 1921–23. Celia wrote that her date was Lee!!! Eight-hundred people attended the eight act program comprised of several dance pieces, a violin and piano duet, a quartette, a one act comedy, and The Sultans of Syncopation.

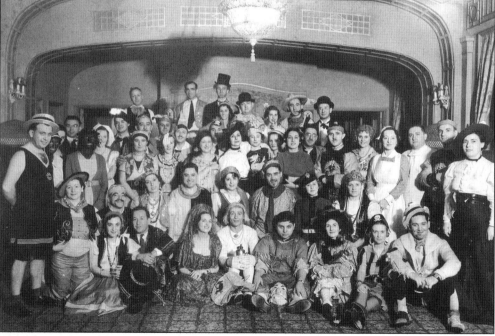

The Thorpeian Athletic Club was named after the multi-talented star of the 1912 Olympics, James Francis Thorpe. It was active from 1919 to 1935, and had sports events, picnics, banquets, and dances. This is the October 1934 Halloween party. Between the two black-faced characters on the left side in the fourth row is Rabbi J. Goldstein.

The Ivre club (which means Hebrew) had chapters in Omaha, Lincoln, Des Moines, and Sioux City. They visited each other's cities for sporting contests and dances. This Bi-Lingual Oratory Contest of English and Yiddish reflected changing language use and the importance of debate in education and leadership preparation. Every Labor Day, the four branches had an annual conclave. Membership expanded to newly married couples. They disbanded in the 1950s.

Jewish Community Center
Omaha, Nebr.

SECOND ANNUAL

Bi-Lingual Oratory Contest

Sponsored by Compeer Chapter, National Order of Ivre

FEBRUARY 5, 1930, 8:30 P. M.

Mr. Harold Farber, Chairman

I. Introductory Remarks.........................Chairman

II. Overture Favorites.........................*Victor Herbert*

III. Yiddish Orations—
 (a) Shall We Divorce Ourselves from the Palestinian
 Mandate?Irvin Soiref
 (b) Eretz Yisroel as a Spiritual Center of World Jewry
 Rose Sofler

IV. Violin Solo—"Spanish Dance No. VIII"...........*Sarasate*
 Mr. Nate Sekerman, accompanied by Sarah Rae Fish

V. Orchestra Selection—"Merely Mary Ann"...........*Hurwitz*

VI. English Orations—
 (a) Jewish Education a Decisive Factor in Jewish Sur-
 vivalPearl Marcus
 (c) A New Jew.........................Sara Jacobson
 (d) Louis Marshall.........................Sarah Pollay
 (e) The Significance of the Jewish Community Center
 Dora Freshman

VII. Orchestra Selections—
 (a) Vienna Tales*Straus*
 (b) Liebestraum*Liszt*

VIII. Presentation of the Compeer Medals...............Chairman

Judges: Rabbi Abraham Bengis, Mr. Judah Wolfson, Mr. I. Morgenstern

Orchestra

Sara Rae Fish, *Piano* Sidney Cohn, *Clarinet*
Lilly Epstein, *Violin* Nate Sekerman, *Violin*
Beulah Kay, *Violin* Max Weinstein, *Trumpet*

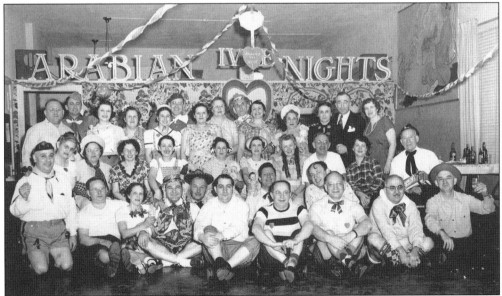

Lincoln Ivre held a formal New Year's Eve banquet at the Cornhusker, Lincoln or Capital Hotels accompanied by skits, costume parties, and bridge. Early members were Eli Evnen, Sam Garson, Abe Friedman, Abe and George Novicoff, Jack Chesin, Jack Singer, Jake and Ben Polick, Ben Shapiro, Louis Finkelstein, Max Shapiro, Hyman Rosenberg, Dave and Harley Davidson, Nate Mozer, Herman Ginsburg, Ben Ross, Ben Ellis, Harry Kuklin, Nick Sherman, Hyman Bricker, and Abe Cohen.

Menu

—

Fresh Fruit Cocktail

Green and Ripe Olives

—

Broiled Tenderloin of Trout

French Fried Potatoes

Peas in Butter

—

Lettuce and Tomatoes

Thousand Island Dressing

—

Neapolitan Ice Cream

Assorted Cakes

Coffee

Program

—

Toastmaster - - -	David Beber
Invocation - - -	S. I. Silberman
Address - - -	Sam Beber
Impromptu Remarks	
Novelty Monologue -	Rose Davidson
Address - - -	Henry Monsky
Benediction - -	Nathan Bernstein

AZA was formed in 1923 by Sam Beber and Nathan Mnookin at Central High School. It was soon adopted by B'nai B'rith as its youth arm. Ritual involved using Hebrew names for elected officials and naming chapters after Jewish cultural icons. The first annual banquet on July 6, 1924, at the Hotel Fontenelle, came at the culmination of a convention that started on July 4.

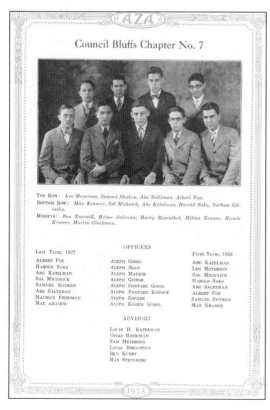

In 1928, AZA published a well-illustrated year book with photographs of the members of the organization that had grown phenomenally to 71 chapters. Omaha, the founding city, contained Chapter No. 1 and would expand to have three chapters. This is the Council Bluffs Chapter No. 7, just across the Missouri River.

Lincoln AZA, Chapter No. 3, won the State AZA Basketball title in 1925. In the front row are Irvin Rubinow, Lou Marx, Eddie Alberts, and Jake Breslow. In the back row are J.J. Max, Carl Sokolof, Joe Mozer, George Novicoff, and Harry Breslow.

The AZA Sweetheart Dance was an institution, as this 1947 picture suggests. The competition and rivalry was generally friendly. Pictured here are Beke, Reva, Jerry, Margie, Arlene, and Dorothy. The processions were attended by friends and relatives of the Sweetheart and beaux, as well as the members.

AZA PRESENTS THE TENTH ANNUAL

Stan Widman
Harold Friedman

Howard Kaslow
Jack Oruch

100

KING DANCE

EDDY HADDAD'S ORCHESTRA

HIGHLAND COUNTRY CLUB
128TH AND PACIFIC STS.

Couples $1.75
Stags Extra

APRIL 4, 1955

9:00-12:00
Semi-Formal

Dancing has prehistoric romantic and military roots. Selling tickets and advertising for the program were fundraisers. The challenge was to distinguish a dance from a prior dance, sort of one-upsmanship. A way to do that was bring in a new band. Small dance cards with a string attached to a thin pencil were produced for the prestigious dances. The announcement is for the 1955 AZA King Dance.

B'nai B'rith Girls, BBG, was established in the mid 1940s. Pictured here is the Hodi Chapter, 1955. B'nai B'rith Youth Organization had a pyramid structure that had local, regional, national, and international components, and served as leadership training for teenagers and young adults. Omaha and Lincoln chapters were in the Cornbelt Region. BBG and AZA held "socials," dances, and annual banquets featured the ritual Sweetheart ceremonies.

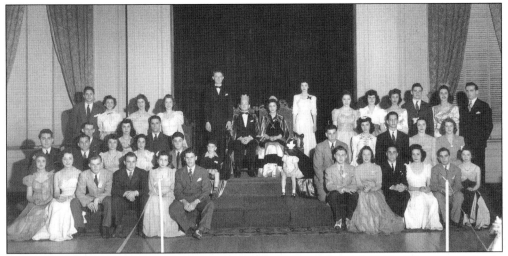

The Jewish Youth Council operated from the early 1940s to the mid 1960s. This picture is of a conclave in April 1942 at the Fontenelle Hotel with the King and Queen in the center. It was a form of Junior Jewish Federation, and provided leadership training. Groups like AZA, BBG, RoNoh, Elesay, and Tikvas sent representatives.

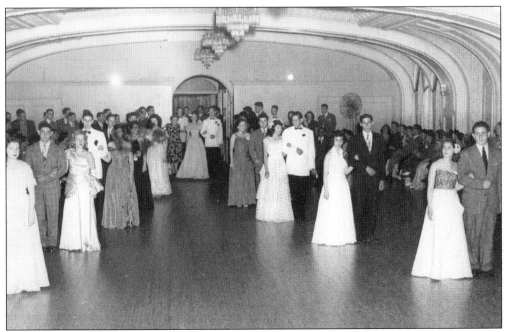

Round Table of Jewish Youth Dance, 1947. Dances were socializing and courtship events designed to promote marrying within the faith. The Round Table, formed around 1933, included 28 Jewish youth organizations, published a Bulletin, and lasted to the late 1940s. It took some of its inspiration from the romantic Arthurian legend.

Most Jews attended Central High School. Two of its 11 graduates in the 1876 first class were Jewish. Some attended Commerce or Technical High, South High, and later Westside and Burke. In 1940, Pi Tau Pi fraternity included Bill Stiefler, Stuart Simon, Howard "Bud" Barish, Edward Malashock, Alan Jacobs, Irving Malashock, Barton "Bucky" Greenberg, James Robinson, Yale Trustin; and (in front) Richard Newman, Charles "Buddy" Rosenstock, Julius Cohen, Calvin "Nick" Newman, and Arthur Kulakofsky.

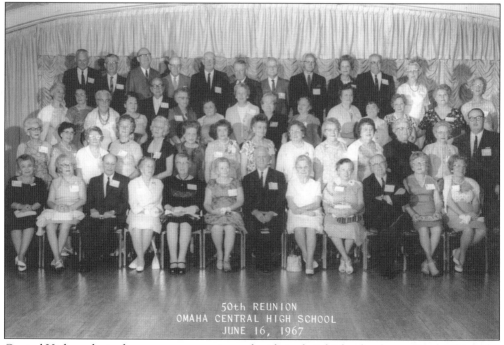

Central High graduates have strong memories and pride in their high school experience. This is the Class of 1917 50th reunion in June 1967. About 13 of the 52 alumni pictured here are Jewish.

94

Elmer Greenberg (1909–95) played football at Central, from which he graduated in 1926. He played football for Nebraska from 1928 to 1930 and made All-American honors. He founded Greenberg Fruit Company in 1936 and retired in 1989. In 1979, he was inducted into the Nebraska Football Hall of Fame.

Pi Lambda Phi, an international social fraternity, was founded at Yale University in 1895. It was established at Creighton University in 1929 as the 200th chapter in the organization, and its members were Jewish. Creighton was a Jesuit University and its professional schools, law, medicine, dentistry, and pharmacy were popular choices for east coast Jews stymied by the quota system.

Sigma Delta Tau, SDT, was a Jewish sorority at the University of Nebraska. This picture from 1932 includes Ruth Bernstein, Betty Segal, Ruth Fox, Mother Baer, Gwendolyn Myerson, G. Riseman, Ruth Cohen, Rosella Perliss, Judith Sobaroff, Rose Steinberg, Florence Smeerin, Jo Monheit, and Ruth Greenberg.

Zeta Beta Tau, a Jewish fraternity founded in 1898, colonized the University of Nebraska in 1922. This picture of an early 1940s pledge class taken in the fraternity house includes Omahans Alvin Nogg, Kevee Kirshenbaum, and Bud Rice.

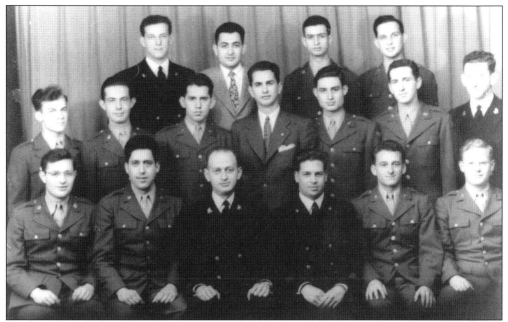

This picture is of the founding members of the National Jewish Medical Fraternity at the University of Nebraska College of Medicine, 1945, Phi Delta Theta. This photograph includes E. M. Malashock, M.D.

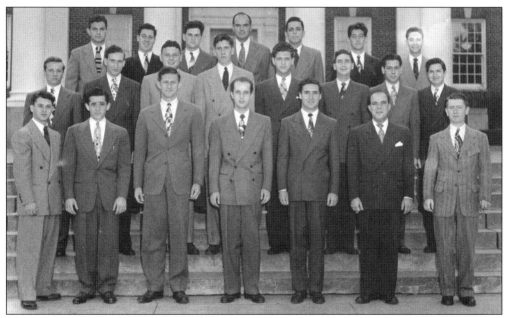

Beta Tau Kappa was a Jewish Fraternity at the University of Omaha in 1948. OU became the University of Nebraska at Omaha in 1968. Left to right, pictured are: (first row) Milt Soskin, Hy Gendler, Jay Chasen, Marty Haykin, Mort Kaplan, Harvey Roffman, and Shelly Coren; (second row) Eddie Kuklin, Willis Epstein, Marvin Kohll, Marvin Hornstein, Morrie Abrams, Marty Colton, and Harold Novak; (third row) Marvin Dienstfrey, Jerry Guergil, Harold Abrahamson, Advisor, Pete Knolla, Gordon Bernstein, Fred Schuerman, and Sidney Neurenberg.

The JCC basketball team in 1929–30, like the other clubs, traveled to play games in Lincoln, Kansas City, and St. Louis: it was part of the lure of being in a league. Pictured, from left to right, are: (back row) Ed Burdick, Coach, Morris Bloom, Sam Katzman, Max Altschuler, Iz Bogdanoff, and Sam Zweiback, Manager; (front row) Manny Goldberg, Iz Schreibman, Johnny Rosenblatt, Jake Sadofsky, and Jay Stoler.

Car dealers, clothing stores, markets, and insurance companies sponsored teams. The Shames Body and Radiator baseball team from 1928–29 includes the following: (front row) Earl Siegel, Sam "Hawkins" Epstein, Izadore "Boggie" Bogdonoff, Sammy Yousem, Morrie "Moze" Franklin, and Izzy Schreibman; (back row) sponsor Max Shames, manager Sam Zweiback, Lester Giventer, Morrie "Pooch" Bloom, Max Altschuler, Sam "Shomie" Osterman, Lee Weitz, and Sponsor Shop Foreman Glen Fox.

Louis Market sponsored these bowlers. The Rose Bowl was one of several bowling alleys in Omaha. These bowlers are Justin Stern, Sam Rosenstein, Jack Melcher, Harold Bloom, and Abe Bear. Bowlers had leagues and traveled around the country for tournaments. Harold and Dina Bloom were honored in 1987 for having started the Junior B'nai B'rith Bowling league in 1946 and guiding it well into the 1980s.

Annual banquets, trophies and awards, All Star Recognition, and the Hall of Fame are special sportsmen's rituals. Pictured, left to right, are: (back row) Sam Katzman, Boggie Iz Bogdanoff, Jerry Berman, Steve Lustgarten, Kevee Kirshenbaum (Cal Kirshen), Dr. Abe Faier, Bucky Greenberg, and Sol Yaffe; (front row) Sandy Brophy, Ed Belgrade, Linda Gordman, Irv Yaffe, and coach Chuck Arnold.

Psi Mu, a JCC club, fielded baseball and basketball teams. This 1930 team, from left to right, includes: (back row) Leo Berman, Earl Siegal, Joe Turner, Louis Loriman, Morrie Bloom, and Buzzie Siegel; (front row) Henry Ginsberg, Sam Epstein, Aaron Epstein, Iz Bogdanoff, Jay Stoler, and David Bleicher.

The Psi Mu team had a reunion in 1975, 45 years after the previous picture was taken. Many of them were still active athletes.

Six

COMMUNAL
PHILANTHROPY
THE TZEDAKAH OF EVERYDAY LIFE

Almost all Jewish organizations have a significant Tzedakah component. The blue Jewish National Fund pushka or Tzedakah (charity) box, a receptacle for loose change, marks the kitchen and mantle piece in many Jewish homes.

Fund raising by volunteers to support worthy causes is ubiquitous. Invitations to events will announce "No solicitations to be made." A European model of Jewish communal organization, shtetl, and ghetto, the authority of the rabbinate and the Kehilla, was not transferred to the Midwest. America is an open society, with a low level of religious discrimination and a constitutional separation of church and state. Yet the Jewish idea that Jews take care of Jews combined with Maimonides prescription of charitable giving prevailed.

Jews in London, Berlin, New York, and smaller cities, including Omaha and Lincoln, Nebraska, created a centralized agency to collect and distribute funds to the local Jewish needy and to stay connected with the needs of the Diaspora and Israel. Centralization, scientific welfare, was based on the early 20th century goal of eliminating multiple and competing appeals and to reduce the overhead, the cost of collecting charitable contributions. The result is a partnership between professional guidance and substantial volunteer lay involvement.

Closely linked with organized charity was the Jewish Community Center movement, sometimes associated with Mordecai Kaplan, in which the Jewish Community Center would be a communal establishment providing for education, recreational and social contact, all in a distinctly Jewish environment.

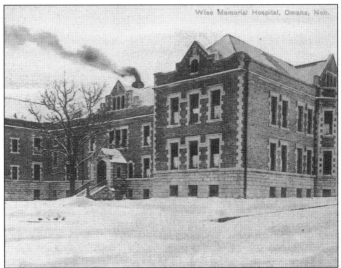

Wise Memorial Hospital, named after the Reform movement leader, opened in 1899 and ensured Jewish patients and doctors ready access to health care. This building at Twenty-Fourth and Harney opened in 1908 due to the fundraising of Edward Rosewater and Arthur B. Brandeis and the generosity of Abraham Slimmer, an Iowa philanthropist, and Guy Barton of Omaha. It closed in 1930. (Postcard courtesy of Burnice Fiedler.)

A central location for Jewish adult education, sports, recreation, and library facilities was an early 20th century goal. In Omaha it began with the Omaha Jewish Institute, depicted here, that opened in 1906. Fundraising for a specially designed building was a continuous project with several setbacks.

A devastating tornado struck the city on Easter Sunday, March 23, 1913. It cut a several block wide, 4-mile-long swath of destruction, killing over 150 people, including 24 in the Jewish neighborhood, and diverted fund raising for the Jewish Community Center. (Postcard courtesy of Burnice Fiedler.)

American entry into World War I in 1917 further delayed fund raising and construction. The Jewish community rented space at the Wollington Inn, Lyric Building, Arthur Building, Germania Hall, and Crounse Hall. The Jewish Community Center, propelled by a $50,000 gift from Morris Levy, founder of the Nebraska Clothing Company in 1886, opened in 1926 at Twentieth and Dodge across from Central High School.

APPLICATION FOR MEMBERSHIP

NO. *1234* **JEWISH COMMUNITY CENTER OF OMAHA** DATE *12-19-26*

I hereby apply for *Jr. G.* Membership in the Jewish Community Center and agree to abide by the rules and regulations of the organization.

I promise to pay the sum of *Twelve dollars* $ *12 00* per year, payable semi-annually.

Name *Louis Finkenstein* Res. *1102 - No. 24th St.*

Bus. Address - *1114 - No. 24th* Occupation *Truck Driver*

Phone ——— Date of Birth *Nov. 28, '09* Place of Birth *Omaha*

Single or Married ——— Name of Wife ———

Name and Ages of Children ———

Activities Preferred ———

MEMBERSHIP GROUPS
DONOR over $50.00 ACTIVE $50.00
MALE
SENIOR $18.00 JUNIOR A $12.00
 JUNIOR B $6.00
FEMALE
SENIOR $12.00 JUNIOR $6.00

Louis Finkenstein
SIGNATURE OF APPLICANT

Proposed by

Seen here is Louis Finkenstein's 1926 membership card. The Jewish Community Center, across the street from Central High School, had a basketball court, swimming pool, library, theatrical stage, meeting rooms, and was a place that Jewish students naturally gravitated to after school. When the old JCC closed in 1973, some long time members were so nostalgic about the building's influence in their lives that they took home bricks from the demolished building.

Incorporated under the Laws of the State of Nebraska

No. 528

Contribution $30.00

Jewish Community Center
OMAHA, NEBRASKA

This certifies that *H. Kolnick* has contributed

Thirty Dollars

to the Building Fund of the Jewish Community Center,

and is a Building Fund Member. The holder hereof shall be entitled to the privileges incident to "Building Fund Membership" as prescribed in the Articles of Incorporation and the By-Laws. All such privileges shall be personal to the original certificate holder, his heirs, executors, or administrators, and neither this certificate nor any of the privileges enjoyed pursuant thereto, shall be transferable. Voting Unit $25.00.

IN WITNESS WHEREOF, the said Jewish Community Center has caused this certificate to be executed by its authorized officers and to be sealed with the seal of the Corporation on this 29th day of November 1926.

Secretary

Harry H. Lapidus President

Certificates of membership and contribution provided validation to participation and status, an official cachet, for a number of Jewish organizations. This is H. Kolnick's Contribution Certificate of $30 to the Building Fund in 1926 signed by Harry Wolf and Harry Lapidus, two leaders of the Omaha JCC movement. Similar corporate-like documents were used for the Labor Lyceum, Highland Country Club, and various loan associations.

Sixth Annual
Father and Son Banquet

Sunday, November 13, 1927
6:30 p. m.
Jewish Community Center
Omaha, Nebr.

Social workers concerned about the decline of traditional values, unsupervised children, and juvenile delinquency created programs to publicly support family values of which this Sixth Annual Father and Son Banquet in 1927 is an example. There were eats and speeches. The humorous menu included stuffed roast spring chicken (a la laddie), Gravy (a la daddy), and apple strudel (chere maman). This banquet was held annually from 1926 to 1957.

104

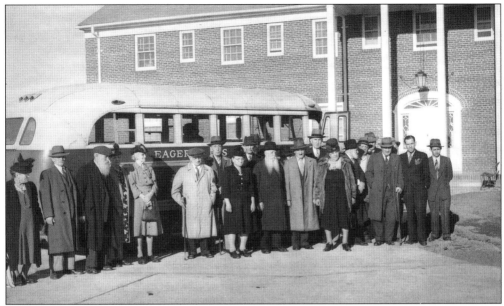

The Daughter's of Israel Aid Society started raising money in 1912 and opened the first Jewish Old People's Home in a converted private residence at Twenty-Fifth and Charles. A state of the art facility, the Sher Home on Fifty-Second Street, named after Dr. Philip Sher (1875–1963), a rabbinically trained physician who devoted himself to Jewish communal activities, opened in 1948.

Rose Blumkin Jewish Home

God's divine promise that the Jewish people shall live forever
has been strengthened by our promise to honor our parents.
This sacred obligation is an essential part of the Jewish character.
We are where we are today
because earlier generations have shown us the way.
We have harvested their work.
We have benefited from their sacrifice.

And now we are called upon to help them.

The current facility is the Rose Blumkin Jewish Home, adjacent to the JCC opened in 1982. This is an architect's sketch. Rose Blumkin's name also adorns the Rose Blumkin Performing Arts Center in the restored Moorish style downtown Astro Theater. Both are named after Mrs. B for her generosity in endowing its good works.

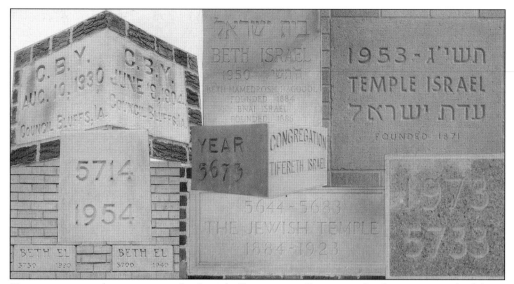

Cornerstones mark synagogues, the Jewish Community Center, and other communal edifices. The ritual includes fundraising, groundbreaking with shiny shovels, ribbon cutting, grand openings, rabbis and cantors attaching Mezzuza's to doorposts, and plaques indicating the names of major donors. Continuity, L'dor V'dor, from generation to generation, is preserved within Jewish buildings with memorial plaques and cornerstones from earlier buildings. (Photos by Oliver B. Pollak.)

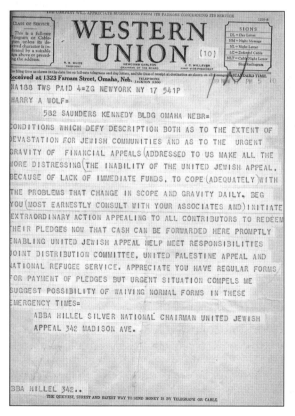

Fundraising connects local interests to international Jewish needs. Omaha maintains a high rate of financial contributions and is on the circuit to be visited by Jewish leaders like Chaim Weizman (1923), Abba Eban, Prime Minister Yitzhak Rabin (1979), and Elie Wiesel more than once. Thousands attended speeches and rallies and made financial contributions.

The communal desire to care for one's own resulted in the formation of The Hebrew Knights of Charity (1869), Young Men's Hebrew Benevolent Society (1897 or 1898), the Hebrew Ladies Sewing Society (1884), and in 1903 the Associated Jewish Charities of which this is the 1915 report. Renamed the Jewish Welfare Federation (1917) and Jewish Federation of Omaha (1940s), it maintains a sophisticated and caring Jewish communal infrastructure.

Report of the

Associated Jewish Charities

of Omaha, Nebraska

‚כל המרחם על הבריות
מרחמין עליו מן השמים'

"Who shows compassion to mankind he shall from heaven compassion find."

Year Ending Dec., 1915

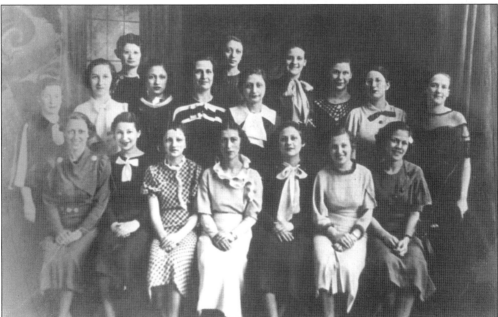

Women, especially those not in the work force, adopted projects through synagogue sisterhoods and local and national organizations to improve the quality of life. The Hebrew Ladies Sewing Society was organized in 1884 and later became the Lady's Aid Society. Pioneer Women, organized in Omaha in 1928 was visited by Golda Meyerson (Meir) in 1932 and 1934. This picture is from about 1939.

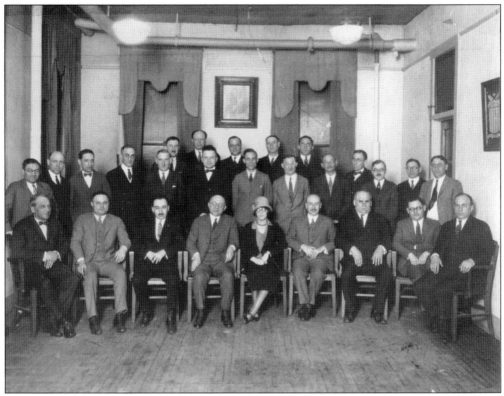

The Jewish Federation Board about 1929. The board contains representatives of all the synagogues and Jewish organizations in the city. The Formal dress of the early 20th century became much more casual by the end of the century. Dr. Philip Sher, in the center, was president. Others in the picture are William Holtzman, Nathan Yaffe, and Harry Lapidus. Theodore Herzl appears in a framed picture in the center.

Jewish Philanthropies of Omaha N̲o̲ 5189

To OMAHA NATIONAL BANK
27-2 OMAHA, NEBRASKA

Omaha, Nebraska February 11 194 8

$150,000.00------

PAY -------------------One hundred fifty thousand and no/100---------------DOLLARS
IN FULL PAYMENT OF ITEMS LISTED ABOVE

Jewish Philanthropies of Omaha

United Jewish Appeal
165 West 46 Street
New York City, New York

TO THE ORDER OF

TREASURER

EXECUTIVE DIRECTOR

Omaha's Jews responded to itinerant solicitors, appeals for assistance from World War I refugees and orphans, extricating German Jews in the 1930s, Holocaust survivors, and beleaguered Jews in other parts of the world. The annual fundraising campaign for local, national, and Israeli needs is a major operation. Jews are especially generous in times of crisis, as this oversize check made out to the United Jewish Appeal in February 1948 indicates.

The Jewish Press

Entered as Second Class Mail Matter on January 21, 1931, at Postoffice of Omaha, Nebraska, under the Act of March 3, 1879

OMAHA, NEBRASKA, FRIDAY, MAY 21, 1948

Vol. XXVI—No. 38

Jewish State of "Israel" Proclaimed

Local UJA Drive Passes the Half-Way Mark

Receipts of some $520,000 in pledges in the current Jewish Philanthropies Campaign pushed the campaign over the half-way mark, Harry Trustin, General Chairman of the Philanthropies, announced.

Mr. Trustin declared that the pledges are most encouraging to date, and represent a 50 per cent increase over last year's cards. Every division is working hard in order to reach the quotas set for them.

"I am sure that we are within reach of our goal of $1,000,000," Trustin asserted. It is not just wishful thinking. It can be reached provided we get proper coverage of cards in keeping with our goal."

Homes for Aged Residents Hold Drive

A most exciting campaign took place at the Dr. Philip Sher Jewish Home for Aged, where some 40 residents joined in making their own contributions in this important campaign. A little over $900 was raised amongst the residents, at a special meeting held by the residents. It is expected that the total amount of gifts will be around $1,000.

Women's Division Leads in Increases

The Women's Division leads all divisions in percentage of increases.

(Continued on Page 11.)

Jews Celebrate Proclamation of Jewish State

New York, (JTA)—The Jewish community in the United States joined Jews in Israel and throughout the world this week in celebrating the establishment of the Jewish state. Special thanksgiving services were held in synagogues over the last week-end throughout the country.

The text of Dr. Weizmann's statement, which was sent to Premier Ben Gurion in Tel Aviv, reads in part as follows:

"On this memorable day, when the Jewish state arises after two thousand years, I send my expression of love and admiration to all sections of the Yishuv and my warmest greetings to its government now entering on its grave and inspiring responsibility. I am fully convinced that all who have will become citizens of the Jewish state will strive their utmost to live up to the new opportunity which history has bestowed upon them. It will be our destiny to create the institutions and values of a free community in the spirit

(Continued on Page 11.)

Constituent Assembly to Draw Up a Constitution Before Next October

Tel Aviv, (JTA)—The state of Israel was born last Friday. The Provisional Jewish Government, meeting in Tel Aviv on the eve of the Sabbath, on the fifth day of Iyar, 5708—May 14, 1948—announced to the world:

"We, members of the National Council representing the Jewish people in Palestine and the Zionist movement of the world, met together in solemn assembly on the day of the termination of the British Mandate for Palestine, and by virtue of natural and historic right of the Jewish people, and by resolution of the General Assembly of the United Nations, hereby proclaim the establishment of a Jewish state in Palestine to

Third Consecutive Award Presented "Eternal Light"

New York—For the third consecutive year, the Eternal Light program, produced under the auspices of the Jewish Theological Seminary of America, has been awarded first place for excellence in religious broadcasting during the past year, by the Eighteenth Institute for Education by Radio at Ohio State University in Columbus.

Proclamation of Independence of "Israel"

We have decided, relying on the authority of the Zionist movement and the support of the entire Jewish people, that upon termination of the mandatory regime there shall be an end of foreign rule in Palestine and that the governing body of the Jewish State shall come into being.

The state which the Jewish people will set up in its own country will guarantee justice, freedom and equality for all its inhabitants, regardless of religion, race, sex or land of origin. It is our aim to make it a state in which the exiles of our people are gathered together and in which happiness and knowledge shall prevail and the vision of the prophets of Israel shall illumine our path.

At this hour when bloodshed and strife have been forced upon us we turn to the Arabs in the Jewish State and to our neighbors in adjacent territory with an appeal for brotherhood, cooperation and peace. We are a peaceful people, and we are here to build in peace. Let us then build our state together as equal citizens, with equal rights and obligations, with mutual trust and respect, each with a true understanding of the other's needs.

Our laws are dedicated to defending the liberty of our people. If further trials and battles are in store for us, we shall defend with all our might the achievement upon which we place our hope.

Right is on our side... With us are the hopes of past generations of our people. With us is the conscience of the world... With us are deposited the testament of the millions of our martyred dead and the resolute will to live of the millions who have survived. The sanctity of our martyrs and heroes rests upon us and the God of our fathers will help us.

This is the revised text of a declaration issued by the General Council of the World Zionist Organization which met in Tel Aviv from April 5 to April 12, 1948. The General Council consists of 77 members elected by the Zionist Congress, and is the supreme organ of the World Zionist Organization during the time when the Zionist Congress is not in session.

Father Flanagan, Founder of Omaha's Boys Town, Passes Away in Berlin

Boys Town was stunned last week when a cablegram arrived reporting the death of their beloved leader and benefactor, Monsignor Edward J. Flanagan, from a heart attack in Berlin, Germany.

Father Flanagan's death occured last Saturday while he was resting from a busy day shortly after his arrival in Berlin from Frankfort, Germany. He had just com-

Rt. Rev. Msgr. Flanagan

old, in the middle of his 31st year as the founder and director of Father Flanagan's Boys' Home. Since starting the Home with five homeless boys in a house at 25th and Dodge Streets in Omaha on December 12, 1917, he had cared for some 5,500 boys and was now directing the care and education of 450 boys at Boys Town. The Rev. Edmond C. Walsh, assistant director of the Home, is now acting director of Boys Town.

The inspiration that later led to his work for homeless boys

(Continued on Page 11.)

$30,000,000 Needed For Aid for Cyprus Arrivals in Israel

New York, (JTA)—At least $30,000,000 will be required to extend reception assistance to the 28,000 Jews from Cyprus who will begin to enter Palestine after the expiration of the Mandate, Dr. Israel Goldstein, national chairman of the United Palestine Appeal, said at a dinner in his honor. He emphasized that most of the funds will have to be raised in the U. S.

First Festival of Jewish Music Held in Canada

Toronto, (JTA)—The first Canadian Festival of Jewish Music was held here at Holy Blossom

Weizman Is Head of Provisional Govt. of "New Israel"

Tel Aviv, Israel, (JTA)—Dr. Chaim Weizmann, veteran Zionist statesman who has worked for the establishment of a Jewish state in Palestine since the turn of the century, was elected this week President of the Provisional Government of Israel at a special session of the 37-member National Council.

A motion calling for his election to the Presidency was made by Dr. Felix Rosenblueth, Minister of Justice, who stressed that the "first step of the state of Israel must be linked with the name of the man who has done the most

Dr. Chaim Weizman, President of Israel

for Zionism." Premier and War Minister David Ben Gurion seconded the motion asserting that "although sometimes we had differences of opinion, fortunately full agreement was always reached in the end.

(Continued on Page 11.)

Three Short Films Are Made by Two Studios In Behalf of UJA

Three of Hollywood's top-ranking personalities—Glenn Ford, Edward G. Robinson and Robert Ryan—are the stars in three new documentary film shorts which have just been completed by Columbia Pictures and the RKO Radio Pictures studios in behalf of the $250,000,000 UJA objective.

The three films, which will be shown in New York and 600 other cities throughout the country to stimulate maximum response to the United Jewish Appeal, depict dramatic highlights of the far-flung relief, rehabilitation and resettlement programs carried on by the UJA.

U. S. Recognizes Provisional Government of Israel as the De Facto Authority

By CHARLOTTE WEBER
(Jewish Telegraphic Agency Correspondent)

Washington, (JTA)—The United States Government ten minutes after its establishment recognized the new Jewish state of Israel as the de facto authority in Palestine. Presidetial press secretary Charles G. Ross announced that the President had approved the following statement:

"This government has been informed that a Jewish state has been proclaimed in Palestine, and recognition has been requested by the Provisional Government thereof.

"The United States recognizes the Provisional Government

Settlement in Honor of Dr. Emanuel Neumann

A new suburban settlement

British Drop Blockade of Palestine

London, (JTA)—The British land-sea-air blockade of Palestine ended with the termination of the Palestine Mandate and no attempt will be made to interfere with Jewish immigration, Defense Minister A. V. Alexander announced in Commons this week.

Although the British will not permit the port of Haifa to be used for the disembarkation of immigrants during the period of evacuation of British troops, civilian personnel and supplies, the Jews may use any other port in the country for this purpose, he emphasized.

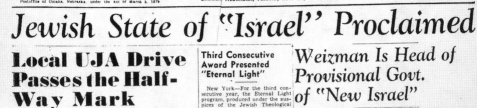

The press around the world heralded the establishment of the State of Israel. In Omaha there was added poignancy as one of the Omaha Jewish community's greatest friends, Father Flanagan, died. Henry Monsky, his confidante, had died the year before.

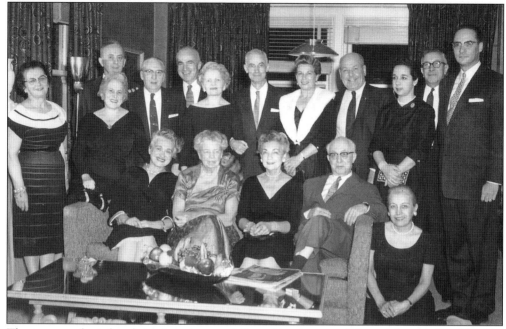

The success of war bonds in America was followed by the appeal for purchasing Israel Bonds. Teas, luncheons, and banquets with outside luminaries honoring prominent Omaha citizens generated the enthusiasm for further donations. This picture taken in 1958 includes Ruth Nogg, Eleanor Roosevelt, and Dr. Abe Greenberg.

Paul Veret was a familiar and friendly face at the downtown Jewish Community Center. This is a portrait of the Director of the Omaha Jewish Federation from 1938 to 1970. He took particular care to establish a library on a sound basis of continuity. (Photo by Oliver B. Pollak.)

The Jewish Community Center Library at Twentieth and Dodge had an impressive collection of educational and recreational 16 millimeter films and Yiddish and Hebrew long playing 33 speed records. The current library is named in honor of Rabbi Myer Kripke and his wife Dorothy, author of several children's books. With over 40,000 books and other library resources it is a major Judaica resource in the Midwest.

This is an announcement of speakers appearing at the Jewish Community Center. The Jewish Community Center is a forum for local and circuit dramatic, music, dance, films, and presentations by prominent writers and intellectuals, and a wide range of educational and cultural programs. For the last 20 years, the month before Chanukah has been designated as National Jewish Book Month. An annual Women's Luncheon features a prominent author.

THE CENTER FORUM

Season 1946-7

• •

Season Tickets . . . $3.60
(Tax Included)

• •

JEWISH COMMUNITY CENTER
101 North 20th Street
OMAHA 2, NEBR.

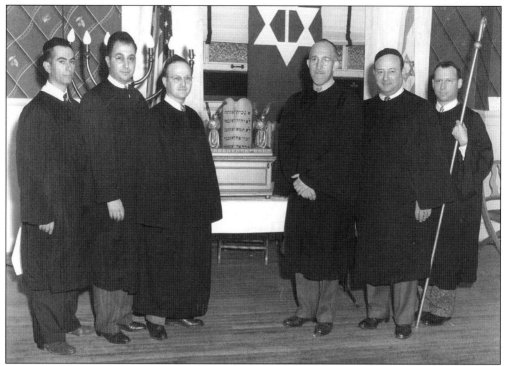

The B'nai B'rith was formed as a men's fraternal organization in New York in 1843 by German Jews. It also offered insurance benefits. The first Omaha Lodge was established in 1884. It flourished in small towns. This is a picture of the Omaha Ritual Team inducting members in Fremont. It includes Hy Shrier, Mike Coren, Joe Hornstein, Earl Siegel, Harry Duboff, and Moe Kagan.

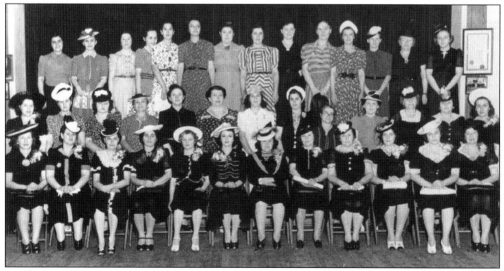

South Omaha B'nai B'rith Women, December, 1940. A major reason for the proliferation of B'nai B'rith activities in Nebraska was the missionary-like work of Henry Monsky who would go by train and car to many smaller communities and urge the Jewish community to recruit members and establish a lodge. There were over 42 members of the men's lodge, No. 1445.

District Six, comprising the Midwest, with headquarters in Chicago, held its annual convention in Omaha in 1960. The bunting and posters above the stage in the Civic Auditorium lionize Philip Klutznick, Henry Monsky, and Dr. Abe Greenberg.

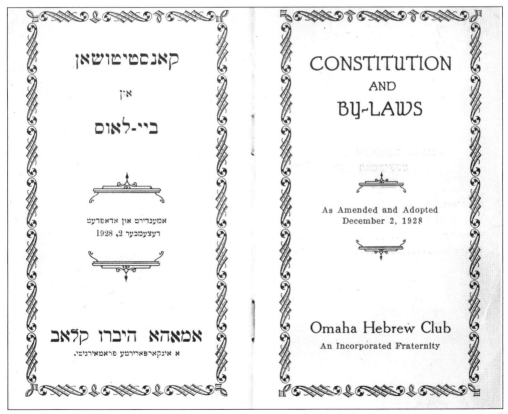

The Omaha Hebrew Club was formed in 1892 as a protective and insurance society. It catered to Eastern European Jews while the B'nai B'rith was dominated in its early years by German Reform Jews. It had 225 members in 1907, 600 by 1922, and provided sick and death benefits insurance. Their annual summer picnics attracted as many as 4,000 people. The group was moribund by the 1950s.

Chevra Bikur Cholim was an organization started in 1885 by Hungarian Jews to visit the sick. This picture of the Women's section includes Mrs. Zalkin, Mary Wine, Sophie Novicoff, Sara Epstein, Fanny Cohn, Jean Epstein, Mrs. Goodbinder, and Mrs. Lippert.

First Annual
"Give or Get" Luncheon
Omaha Chapter Hadassah
May 18, 1932.

Hadassah, The Women's Zionist Organization of America, was founded by Henrietta Szold. By the late 20th century it was the largest volunteer women's organization in America. It raises money for medical care in Israel. This is Omaha's First Annual Hadassah Donor Luncheon, May 18, 1932. Hadassah maintained a thrift shop for many years and its sign read, "Hadassah BARGAIN BOX, *Nearly News are Good News!* Proceeds to Medical Research."

JUNIOR HADASSAH COSTUME PARTY 1927

Junior Hadassah Costume Party, 1927. Just as men's organizations had parallel Women's organizations, adult organizations frequently had parallel youth branches, the latter frequently using English for discourse rather than Yiddish.

The National Council of Jewish Women founded by Hannah G. Solomon in 1893 initially established a section in Omaha in 1896. They identify social service projects including the elderly, nutrition, women's health, child care, literacy, and raise money to address the particular problem. Here they are visiting in 1959 the Senior Citizen room that they sponsored at the Jewish Community Center. Several Omaha members had held office in the national organization. NCJW maintained the Council Thrift Shop for many years.

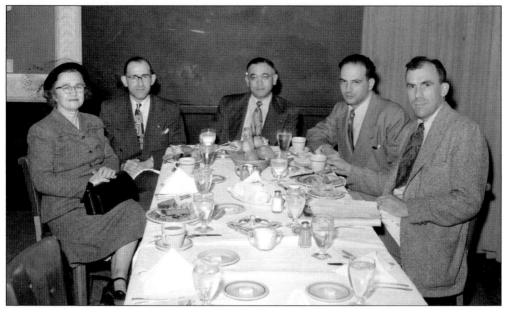

The first Zionist meeting in Omaha was held about 1895. Around 1903, a half dozen Zionist groups formed a council. Financial support was given through the Jewish National Fund and Jewish Colonial Trust. Support went to agricultural, tree planting, health, and educational projects. Pictured here are Ethel Levenson, unidentified, Sam Rice, unidentified, and Ephraim Marks. The unidentified people in this 1949–50 picture are probably Zionist visitors from out of town.

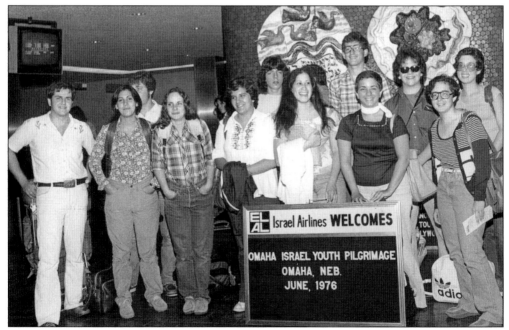

Several Omaha Zionists visited Palestine in the 1920s. Missions to Israel of youngsters and adults, sponsored and subsidized by the Federation and other agencies, are a sign of support for the Jewish homeland. The goal is to reinforce Jewish identity and create a life-long attachment to Israel. By the 1990s, many college students were spending a year at an Israeli university.

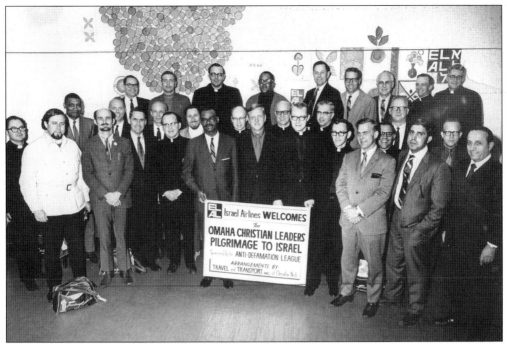

The Anti-Defamation League's continuing program of public education and dialogue between various ethnic and religious communities included sponsoring the 1970 mission of Christian clergymen to Israel.

Asking for and making contributions are *mitzvots*. A popular fundraiser has donors sponsoring walkers, runners, swimmers, and bicyclists in support of social, health, and cultural causes. Here the hardy band in the early 1990s prepares to go on a combination walk and run. Several of the participants have run in east coast marathons. The Federation seeks pledges on the phone during its annual Super Sunday.

The emergence of women in leadership positions in broad Federation activities started in 1974, when Mary Arbitman Fellman was elected Federation president. In Lincoln, this occurred in 1987 when Betty Polsky became president. Her husband Hyman had been Lincoln Federation president in 1965. The Polsky's are pictured here. In 1989, wife and husband, Ruth and Irvin Goldenberg, served as co-presidents. Women have been elected as presidents of several Nebraska congregations.

Forrest Krutter, born in Boston and educated at Massachusetts Institute of Technology and Harvard Law School, is the president of the Omaha Jewish Federation, 1999–2002. He came to Omaha in 1982 to work for the Union Pacific Railroad and is now corporate secretary of Berkshire Hathaway Inc. He is one of the few people not native to Omaha to be elected to lead the Federation.

Seven

JEWISH CULTURE
EDUCATORS, WRITERS, MUSIC, ARTISTS, THEATER, AND FILM

Jewish culture is expressed in Yiddish, Hebrew, and English, in poetry, plays, short stories, and novels. It is revealed in clay, bronze, oil, water color, acrylic, wood, hand made paper, and photography. It appears on the theater stage, television, and the movie house screen. It is produced locally and on the east and west coast. It is amateur and professional. Omaha audiences are discerning and forgiving. Until recently, synagogues had stages built into the design of the social hall. Community centers contain theaters and auditoriums. Public performance and programs of music, dance, and drama are a normal expectation. Although many creative individuals may leave Nebraska for more culturally vibrant and experimental metropolises, the Omaha environment and ambiance frequently left an indelible impression on their art.

Many educators have found Nebraska a friendly place to teach students and adults, and to expand their own horizons of research and professional development. Nebraska Jews have been fortunate to benefit from the establishment of Jewish studies programs at Nebraska's three largest universities. The Jewish community is committed to continuing religious and secular cultural education for out of school adults. Programs at the Jewish Community Center and university campuses promote deeper and wider knowledge of Judaism.

Jewish culture from outside the region is brought to Omaha with regularity to eager audiences. Touring groups and individual artists and scholars come regularly from Israel and other centers of Jewish culture.

The Logasas arrived in Omaha in 1886. Hannah Logasa (1879–1967) worked at the Omaha Public Library from 1900 to 1913, and then went to the University of Chicago Library where she pioneered in the field of school librarianship for junior and senior high schools. She published several reference books starting in 1924, and by the 1960s her *Historical Fiction* was in its 10th edition.

Murray Frost (1937–2000) with a Michigan State doctorate came to Omaha as a researcher for the University of Nebraska at Omaha. He worked as a demographer for the Jewish Federation and the United Way of the Midlands. He was an internationally recognized expert in Jewish philately. He is shown here with Belva Plain during Jewish Book month. His wife, Marlen, was the Early Childhood Director at the JCC Preschool, 1970–90.

Menachim Mor, historian, first holder of the Klutznick Chair in Jewish Civilization at Creighton University in 1987, returned to Israel and became Vice Chancellor at Haifa University. His successor, inducted in 1995, was Harvard trained Biblical scholar Leonard Greenspoon. Here Greenspoon portrays Philip Klutznick at Joslyn Museum Chautauqua in 2000, introduced by Oliver B. Pollak and sponsored by the Nebraska Humanities Council. (Photo by Molly Fisher.)

Rabbi Jonathan Rosenbaum came to the University of Nebraska at Omaha in 1976 to direct a program in Jewish studies established with Federation seed money. He took a Chair at the University of Hartford in 1986, and became president of Gratz College in Pennsylvania in 1998. Rabbi Richard Freund succeeded him in Omaha and Hartford.

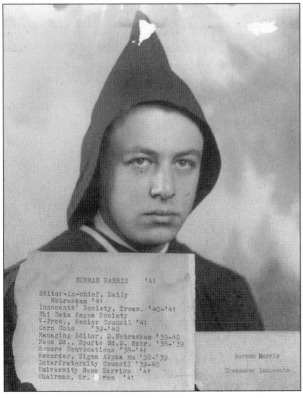

Norman and Bernice Harris prospered in business. In 1992, they established the Norman and Bernice Harris Center for Judaic Studies at the University of Nebraska-Lincoln. Norman Harris is depicted here in the garb of the UNL honorary society, The Innocents. Although the Jewish student population at UNL is small, the program has grown to include local outreach as well as achieving an international reputation. The University of Nebraska Press has become a major academic publisher in the field of Jewish studies.

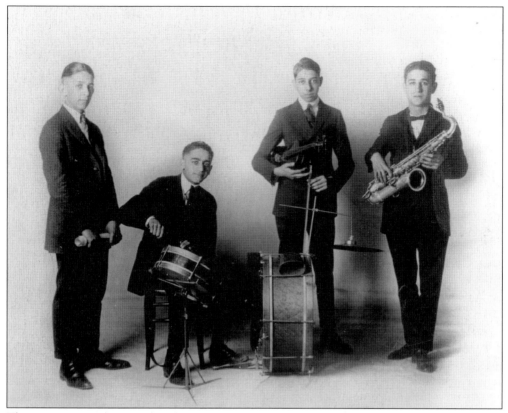

There are many photographs of music teachers and adolescents at their violins and pianos. Musical instruments in the home, especially the piano in the parlor, were symbols of attaining middle class status. "Learn to play a musical instrument and you will always have friends" was a common refrain. Some children flourished, playing in local bands and orchestras. The Al Finkle, Ben Kayer, Fred Kurtzman, and Dave Fogel band was popular.

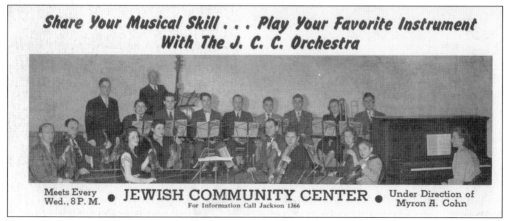

This advertisement for the Jewish Community Orchestra directed by violist Myron A. Cohn, who also played violin with the Omaha Symphony Orchestra, is printed on blotting paper, a common method of merchandising before the introduction of ball point pens.

Tuffy Epstein had his first professional gig at the age of 15 in 1951, playing at a New Year's Eve Jewish wedding. His drummer was Richard Fellman. In 2001, his group is called Tuffy's Klezmorin. Deborah Greenblatt performs professionally with her husband and children. Here Tuffy and Deborah accompany the internationally acclaimed David Amram at the Amram Concert at the Jewish Community Center in 1987.

Victor Yampolsky, a Russian émigré, has been music director of the Omaha Symphony since 1995. His vibrant European style has introduced verve, energy, and a Russian flavor to the repertoire. Another Jewish performer in the orchestra is Willis Ann Ross, who has performed with the symphony as a flutist since 1964. The current symphony president is Fred Bronstein. Earlier Jewish directors included Joseph Levine, 1958–69, and Yuri Krasnapolsky, 1970–75.

Yiddish theater in Omaha was produced locally by amateurs and professionals and benefited from traveling Yiddish theater companies, especially those sponsored by the Workmen's Circle. This photograph is a scene from a performance by the Workmen's Circle Dramatic Club. The Omaha Playhouse performed the plays of Sholom Aleichem in English in 1962.

The Metropolitan, Standard, and Centennial Clubs preceded the Highland Country Club, with predominantly or exclusive Jewish membership. The Highland opened in 1924 in response to restrictive practices at other established country clubs. The need for a Jewish country club is no longer pressing, and in 2000 the golf course at Pacific and 132nd was renamed the Iron Wood, and no longer caters specifically to Jews. Here the Stagettes perform a parody.

Joanne Schmidman organized the Omaha Magic Theatre in 1968. She graduated from Central High School and Boston University. Much of its repertoire is experimental, inviting audience participation and raising pressing social issues such as violence in the family. The group has received funding from many sources and has performed over 100 original plays extensively in America and internationally in Canada and Korea. (Photograph courtesy of playwright Megan Terry.)

Tillie Lerner Olsen (1912–) is the daughter of Sam and Ida Lerner. Although she wrote in the early 1930s, she did not receive recognition until the 1960s, and international acclaim in the 1970s. *Tell Me a Riddle* had been made into a movie, and *I Stand Here Ironing* has frequently been performed on stage. Here she is with Oliver B. Pollak in October 1996 at the Nebraska Jewish Historical Society.

Seen here is Saranne Gitnick of the Kulakofsky family. She is the wife of Nebraska District Court Judge Jerry Gitnick, second woman to head the Omaha Jewish Federation and Robert Eisenberg, son of Holocaust survivors, and the author of *Boychicks in the Hood: Travels in the Hasidic Underground* (1995). The Gitnicks retired to Arizona. The Eisenberg family had an art gallery in pre-war Hungary and Bob's mother, Bella, opened The Eisenberg Art Gallery in Omaha.

This classic pose was produced either by George Heyn who arrived in Omaha about 1879, or by his brother, Herman Heyn, who also opened a studio. The Heyn Gallery in 1908 advertised "We make photographs that live. Your descendants will think of you if they have your picture." The film industry attracted Jewish entrepreneurs Abe H. Blank and Joseph Coopersmith who owned movie houses and established two charitable foundations.

Joan Micklin Silver (1935–) daughter of the owners of Micklin Lumber, a filmmaker, produced several films including two widely acclaimed productions with strong Jewish content. *Hester Street* (1975) features the culture clash of Eastern European orthodox immigrants, and *Crossing Delancey* (1988) discusses traditional values and intermarriage in late 20th century New York.

The art of story telling has been revived by groups such as the Nebraska Story Telling Festival. Rita Paskowitz, Ozzie Nogg, daughter of Rabbi Alex Katz, and a Creighton University student, Anna Cotton, have presented their renditions at festivals and on the radio. Their stories are frequently about Jewish situations, ranging from the classic Hassidic Chelm stories to the horror of the Holocaust.

Entrance to the Kripke Jewish Federation Library. Unfortunately a substantial portion of older journals are stored in the basement—out of sight, out of mind, and out of use. (Photo by Oliver B. Pollak.)

Selected Bibliography

Auerbach, Ella Fleishman. "Jewish Settlement in Nebraska," (typescript, 1927).

Baer, Max F. *Dealing in Futures*. Washington, D.C.: B'nai B'rith International, 1983.

Bernstein, Nathan. "The History of the Omaha Jews," *Reform Advocate*, 1908.

Chudacoff, Howard. *Mobile Americans, Residential and Social Mobility in Omaha, 1880–1920*. New York: Oxford University Press, 1972.

Clearfield, Elaine Abrams. *But You're Different*. Boulder: Jo's Place, 1995.

Gendler, Carole. "The Jews of Omaha, The First Sixty Years," Master's Thesis, University of Omaha, 1968, and printed in six parts in *Western States Jewish History*, 1973–74.

———. "The Industrial Removal Office and the Settlement of Jews in Nebraska, 1901–1917," *The Nebraska History*, 72, Fall 1991, 127–34.

Levitov, Betty. "Jews: The Exodus People," in *Broken Hoops and Plain's People*. Lincoln: Nebraska Curriculum Development Center, 1976.

Memories of the Jewish Midwest, 1982– .

Omaha Jewish Bulletin, 1916–20 and *Omaha Jewish Press*, 1920– .

Pollak, Oliver B. "Jewish Peddlers of Omaha," *Nebraska History*, 63, Winter 1982, 474–501.

———. "Communal Self Help and Capital Formation: Omaha's Jewish Loan Associations, 1911–1979," *American Jewish History*, 78, September 1988, 20–37.

———."B'nai B'rith in Omaha: 1884–1989," *Memories of the Jewish Midwest*, 4, 1989.

———. "The Jewish Press: Captive or Critic? Nebraska's Jewish Journalism, 1916–1921," *Western States Jewish History*, 27, October 1994, 39–52.

———. "The Education of Henry Monsky—Omaha's American Jewish Hero," in *Crisis & Reaction: The Hero in Jewish History*. Omaha: Creighton Univ. Press, 1995.

———. "The Workmen's Circle and Labor Lyceum in Omaha, 1907–1977," *Nebraska History*, 76, Spring 1995, 30–42.

——— with Leo Greenbaum, "The Yiddish Theater in Omaha, 1919–1969," in *Yiddish Culture*. Omaha: Creighton Univ. Press, 1998.

Rosenbaum, Jonathan, and Patricia O'Connor Seger. *Our Story, Recollections of Omaha's Early Jewish Community, 1885–1925*. Omaha: National Council of Jewish Women, 1981.

Somberg, Suzanne Richards and Silvia Greene Roffman. *Consider the Years, 1871–1971, Congregation of Temple Israel*. Omaha: 1971.

For fiction involving Jews in Nebraska see *The Professor's House* by Willa Cather, works by and about Tillie Lerner Olsen, and Gerald Shapiro's *Bad Jews* (1999).